ADOBE
PHOTOSHOP®
MADE EASY

D1428819

This is a FLAME TREE book
First published 2011

Publisher and Creative Director: Nick Wells
Project Editor: Catherine Taylor
Art Director: Mike Spender
Screenshots: Rob Hawkins
Consultant Mac editor: Aaron Miller
Layout Design: Dave Jones and Jane Ashley
Digital Design and Production: Chris Herbert
Copy Editor: Anna Groves
Proofreader: Dawn Laker
Indexer: Helen Snaith

This edition first published 2011 by
FLAME TREE PUBLISHING
Crabtree Hall, Crabtree Lane
Fulham, London SW6 6TY
United Kingdom

www.flametreepublishing.com

Flame Tree is part of Flame Tree Publishing Limited
© 2011 this edition Flame Tree Publishing Limited

13 15 14 12
3 5 7 9 10 8 6 4 2

ISBN 978-0-85775-260-4

Printed in China

All non-screenshot pictures are courtesy of Shutterstock.com and © the following photographers: A.S. Zain 1 & 19, Dmitriy Shironosov 3 & 242, Peter Bernik 4, Schalke fotografie/Melissa Schalke 5t & 66, Zadorozhnyi Viktor 5b & 104, ARENA Creative 6t & 132, Gregor Kervina 6b & 178, Ivanova Inga 7 & 216, Denis Vrublevski 244, and tkemot 253.

ADVANCED PHOTOSHOP SUBJECTS 216

Photoshop takes more than just a book to learn all of its powerful features, and many professionals admit they only know the parts of it that help them with their work. This chapter does not aim to cover all of the advanced features in Photoshop, but provides an insight into some of them and some direction if you want to progress further. To become a true expert in Photoshop takes years of practice, so this chapter provides an overview of some of the more complicated topics.

INTRODUCTION

Since Adobe Photoshop first appeared in 1990, this image creation and editing program has gradually become a market leader. It has evolved over the years with an increasing quantity of features and terminology that can be confusing to beginners and more experienced users alike. This book aims to clear that frustration and provide a practical education in the use of Photoshop and how it can be used correctly and efficiently.

THE PURPOSE OF PHOTOSHOP

As its name suggests, you'd be forgiven for thinking that Photoshop is only concerned with photographs, but it has a much wider purpose. It has a vast assortment of artwork tools that can transform a photograph with special effects or create a stunning logo. Artwork can be combined with photographs to produce professional-looking images. On the photographic angle, Photoshop has become a powerful tool, which most professional photographers recognize as being able to produce photographs that are more realistic than their cameras can

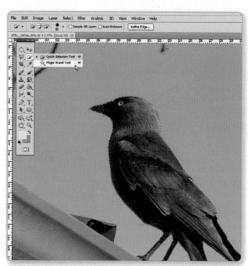

Above: Find out how to select objects in an image, such as this jackdaw, and copy them into other images.

produce. Plus, traditional equipment used by professional photographers can be replicated in Photoshop, including lighting, filters and exposure bracketing. Non-professionals also appreciate the various uses for Photoshop, ranging from making your own family portraits to producing personalized calendars and greetings cards.

NEED TO KNOW

Whilst the ideas for using Photoshop can keep on growing and become more and more sophisticated, the problem with such a program is understanding how to use it and making sure that whatever is created is correct. Most professionals will agree that understanding masks and layers and how to use them in Photoshop is not easy at first. However, this book provides the guidance and practical advice to help make such a dilemma easier to manage. Also, it's essential to have an understanding of the jargon and terminology surrounding Photoshop to avoid moments of frustration and confusion when you're looking for

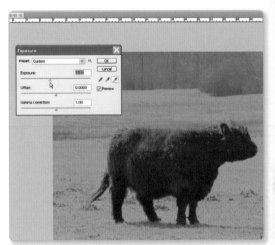

Above: Learn how to use Photoshop's exposure controls to adjust and improve a photograph.

a screen control or trying to understand why an error message is asking you to rastorize an image, so this book includes definitions for typical Photoshop jargon and never assumes the reader should know where a button or other tool is on the screen.

DIFFERENCES

Just like most computer programs, there's rarely only one version available. Photoshop has been updated and changed more than a dozen times since it was first introduced. There are also more supporting programs for Photoshop, such as Lightroom. This book can be applied to all versions of Photoshop Creative Suite (CS), but if you have an even earlier version (e.g. Photoshop 6.0), then the topics covered and information are relevant in many cases. Aside from version differences in Photoshop CS, there are also a few differences between using the program on a PC and on an Apple Mac. The main differences concern keyboard and mouse controls where the use of Ctrl, Alt, Option and Command are different between the PC and the Mac. Whenever a keyboard shortcut is noted in this book, instructions are provided for both the PC and Mac.

SMALL CHUNKS

There is one theme that has been carried through this book. Flick through the pages and there are always short paragraphs describing particular features within Photoshop and how to use them. Upon first sight, it may look like the next 245 pages have to be read in numerical order, but all of the sections are task oriented, so they can be read and practised on their own. Pick out the section on creating a panoramic photograph, for example, and it can be read and used on its own. The only time you will need to refer to another part of the book is when a selection tool is used, which takes up several pages in chapter one and would be a waste of pages to repeat every time it needs to be used.

STEP-BY-STEP

Throughout this book there are step-by-step guides covering everything from creating a bright blue sky in a landscape photograph and producing a collage of photographs to creating a

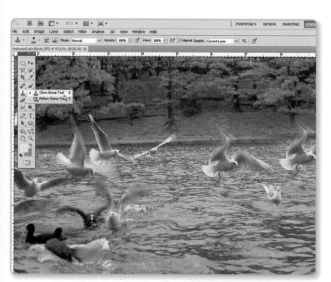

Above: Use the Clone Stamp Tool to copy objects in an image or remove them, such as the birds in this photograph.

company logo and producing a realistic school portrait. Each step-by-step guide explains which menus or buttons to click on and what to expect when you follow the instructions. Any differences between the various versions of Photoshop are explained along with keyboard variations between a PC and an Apple Mac, so you can be confident the step-by-step information can be applied to your version of Photoshop CS. Difficult topics, including creating selections and layers, merging bracketed photographs and applying a radial zoom blur, are all covered in clear and concise steps.

HELP!

If you are stuck on a particular topic, please email Flame Tree Publishing at support@flametreepublishing.com. While we cannot operate a 24-hour helpline for all your Photoshop needs, we will answer your query via email.

RESEARCH AND TRAINING

The contents of this book have been extensively researched to ensure the most suitable and appropriate topics are covered. The author, Rob Hawkins, has taken many of the traditional photographic skills he learnt before digital cameras became popular and worked through Photoshop to see if they can be replicated in this program. He has also taught hundreds of people to use a variety of computer programs and has consequently been able to draw upon this experience of how people learn and how facts need to be clearly explained.

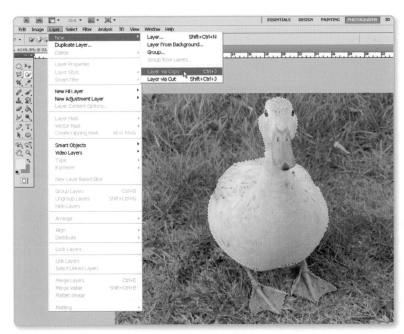

Left: Throughout this book, the complex subject of layers is explained and step-by-step guides provided.

DON'T ASSUME

Whilst most people have now become familiar with using a computer and can not only competently operate a mouse and keyboard, but recognize common terms such as drag and drop and click and hold, Photoshop in particular appears to be a program that carries a high level of expected expertise. Many professionals create the impression that they know everything about the program, but soon realize they know only enough to be able to do their job. There are also many shortcuts that most people are not aware of, which can save hours of time. Whether you are a complete novice or have been creating layers and making adjustments for years, there is certainly something useful in this book to help improve your Photoshop skills.

SIX CHAPTERS

In brief, the contents of this book are split into six chapters, which begin in chapter one with some probing questions concerning the use of Photoshop, what it is and what all the jargon means. The second chapter covers the best techniques for improving an image. Chapter three covers an extensive range of artwork-related topics and shows how professional images can be created. Chapter four is ideal for anyone wanting to practise a number of purposeful tasks in Photoshop, ranging from making a birthday card to creating a collage of photographs from a holiday. Chapter five is where Photoshop's abilities shine, with images containing special and stunning effects. Finally, chapter six provides an overview of many of the advanced topics that are complicated and require experience to understand.

Above: Paintings can be scanned and edited in Photoshop to remove mistakes and change the overall finish.

HOT TIPS AND SHORTCUTS

Within each section of this book, look out for the Hot Tips on most pages, which provide useful hints associated with the topic being covered. There are so many shortcuts and quick techniques available in Photoshop and we've tried to highlight many of them through easy-to-spot Hot Tips. These can often be spotted by flicking through the pages of this book, and in many cases, you don't need to read through the entire section to understand them.

DOWNLOAD AND PRACTISE

If you want to practise using Photoshop with some of the files shown in this book, go to the publisher's website at www.flametreepublishing.com/samples and download the image files (they have a .jpg extension) that are referred to in some of the step-by-step guides.

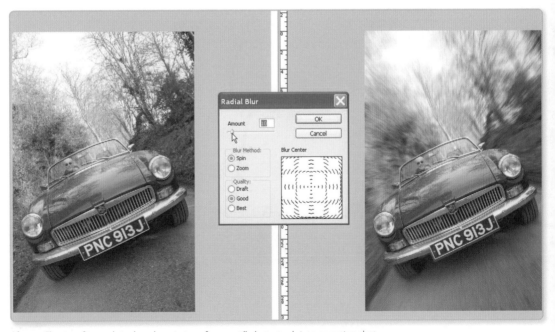

Above: Chapters five and six show how to transform a still photograph into an action shot.

PHOTOSHOP BASICS

WHAT IS PHOTOSHOP?

Most people assume they know what Photoshop can do and what it should be used for, but, unlike simpler programs, such as a word processor, there is no clear definition of what this sophisticated program can do. The following section aims to provide some answers.

WHAT CAN PHOTOSHOP DO?

Photoshop has become an industry-standard program for creating and editing images ranging from artwork to photographs. It can be used to do any of the following tasks:

→ Prepare a photograph to be printed or included in a desktop-publishing program such as InDesign or Quark Express.

→ Correct mistakes in a photograph, including removing dust marks, red eye caused by flash, unwanted objects and straightening the image.

→ Edit a photograph to include more or fewer objects, text, alter its size and shape and change orientation from portrait to landscape or vice versa.

Above: *Car Mechanics* magazine editor Martyn Knowles uses Photoshop to colour-correct photographs before publishing them in InDesign. Photographer Rob Hawkins (on the front cover) uses Photoshop to tidy up his images before submitting them.

⊙ **Create artwork combining text, drawings and photographs.**

WHO USES PHOTOSHOP?

A wide range of professionals use Photoshop, including photographers, magazine art editors and graphic designers. Here are three examples of people who use this program and what they do with it:

⊙ **Photographer**: Motoring photographer and author of this book, Rob Hawkins, uses Photoshop to edit photographs of cars to remove dust marks, unwanted objects and to straighten images. He also uses the program to create action shots of cars from stills, which is fully explained in chapters five and six.

⊙ **Graphic designer**: Paul Swann produces a variety of stationery using Photoshop, ranging from personalized writing sets to old-fashioned wax seals for letters. For more details, visit www.swannofyork.com.

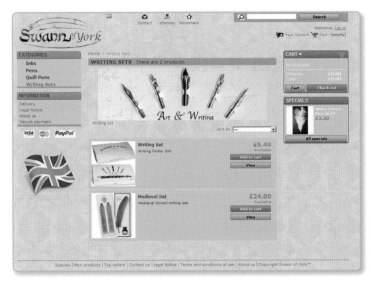

Left: Paul Swann is behind Swann of York, producing a variety of stationery using Photoshop.

⊝ **Magazine editor**: Martyn Knowles is editor and designer of *Car Mechanics* magazine, and uses Photoshop CS3, together with a dedicated colour profile, to manipulate all digital images before introducing them into InDesign. Being 'old school', he likes to save files in CMYK rather than RGB, and introduces TIFF files rather than JPEGs into the design package.

Is Photoshop Only Used by Professionals?

Photoshop is used by a wider variety of people than just professionals. Hobby photographers, artists and students are some examples of people who can use this program in a non-professional capacity to create their own images, artwork and photographs.

WHO IS BEHIND PHOTOSHOP?

Photoshop is owned and developed by Adobe Systems, which was founded in 1982 and officially established the following year in California, USA. The company has been responsible for leading the way in standards for file formats and software, ranging from secure and easy-to-read PDFs and website-compatible Flash plug-ins to industry-standard programs for website design (DreamWeaver), publications (InDesign) and image editing (Photoshop).

A HISTORY OF PHOTOSHOP

Photoshop first appeared in 1990 and, right from the start, was and continues to be developed by Adobe Systems of the USA. The program was initially only available on the Apple Mac computer, but when Photoshop version 2.5 appeared in 1993, it was also available for the PC running Windows, along with computers using IRIX and Solaris systems. New releases of the software progressed to version 7 for the Mac and Windows PC in 2002 before Photoshop was rebranded under the Creative Suite title in 2003 and became known as Photoshop CS. In 2005, Photoshop CS2 was launched for the Mac with OS X and the PC running Windows 2000 or XP. Photoshop CS3 appeared in 2007 and lasted just over one year before CS4 appeared. In 2010, CS5 was launched, with a revised CS5.1 appearing the following year. At the time of writing, CS5.5 was about to be launched.

PHOTOSHOP JARGON

The terminology surrounding Photoshop and image-editing software can seem confusing when first encountered. The following section provides a list of many of the common words and abbreviations associated with Photoshop and explains what they mean.

BMP

This is short for bitmap, a file format for images (usually drawings or artwork). File sizes are usually much larger than other types, such as JPEG.

DPI AND PPI

These abbreviations stand for Dots Per Inch and Pixels Per Inch respectively. An image is made up of dots (also known as pixels) and the more dots or pixels contained in one square inch, the better the quality. For example, most computer printers can print at 300 DPI, cameras usually take photographs at 72 DPI and websites display graphics at around 96 DPI. The DPI or PPI of an image can be altered, which in turn affects the size of it.

EPS

This file format is often known as Photoshop EPS. Programs such as Adobe Illustrator and Freehand also use a type of EPS file format, but this is different. Photoshop EPS images retain some of the editing settings used in Photoshop, so they are a useful type of file format if you want to return to an image and continue editing it.

GIF

Short for Graphics Interchange Format. This file format produces images with small file sizes, so they are ideal for including on a website, but they can only use a maximum 256 colours. The format is useful for simple artwork, images with solid colours and black and white photographs. The common standards for GIF were devised in 1987 and 1989 (GIF87a and GIF89a); the latter allows transparent pixels to be used and can combine several images to produce animation.

GRAYSCALE

Also known as 'greyscale' (with an 'e'), this is the photographic equivalent of black and white. It is called grayscale because the term black and white suggests an image that uses just two colours, whereas grayscale or traditional black and white photographs use a range of colours from black to white with lots of different greys in between.

HUE

This is the colour range used in an image, based on the three primary colours (red, yellow and blue), but expanded to include a fuller range. By altering the hue in an image, more red can be applied, for example, which may turn a yellow object orange.

JPEG

A file format for images, JPEG stands for Joint Photographic Experts Group. Most cameras store photographs as JPEGs and programs such as Photoshop can open these files, which have a .jpg or .jpeg extension (for example, DSC001.jpg).

LAYERS

Photoshop can edit an image by selecting parts of it to change (for example, re-colour, move,

shrink). Each part that is selected can be saved as a layer, so you can select and change it again in the future. Understanding layers is essential to using Photoshop successfully, and this subject is covered in depth in this book.

MASK

This is a selection of part or all of an image, which allows you to change one part of it without changing everything. There are lots of different types of mask, depending on what you want to do. Common types include a layer mask and quick mask.

PICT

This is a file format used by Apple Mac computers and is capable of being included in interactive images, stills for videos, slideshow presentations and CD images.

PIXEL

An image such as a photograph or, in many cases, a drawing is made up of dots, which are known as pixels. If an image is not made up of pixels, it is usually a vector-based image.

PNG

Pronounced as 'ping', this is an abbreviation for a file format called Portable Network Graphics. Images have a .png extension and can store millions of colours. It is useful for creating semi-transparent images for a website.

PSD

Short for Photoshop Document, PSD is a file format for images created in Photoshop. Whilst the program can save images as other file types (such as JPEG or BMP), the PSD file type allows

information concerning layers, masks, clipping paths and other editing data to be retained, making it easier to continue working on it at a later date. The only disadvantage of a PSD file is its size. It is much larger than a JPEG because it can retain more editing information. Most Photoshop professionals save their work in progress as a PSD file, but create a smaller JPEG or TIFF when finished.

RASTER
In brief, raster is another name for pixels. Photoshop sometimes has to convert an image or rasterize it (change it to pixels) to be able to do specific editing.

SATURATION
The depth of colour used in an image, usually related to hue (known as hue and saturation).

SMART OBJECT
Since CS2, a Smart Object is a layer image that contains image data from raster or vector images, such as Photoshop or Illustrator files. Smart Objects retain the source content of an image with all its original features, allowing you to perform editing to the layer without damaging the original image. An image can be opened as a Smart Object, which creates it as the first layer in a new document.

TIFF
Short for Tagged Image File Format, this type of file format for images is commonly used for printing, as it can produce high-quality images. File sizes are much larger than other types, such as JPEG and GIF, and there is no data loss if the image is re-opened several times (unlike other formats). Some digital cameras shoot in Raw mode, which usually saves the file as a TIFF.

UNDERSTANDING THE PHOTOSHOP SCREEN

Photoshop's main screen can initially look confusing until you understand the purpose of the toolbars, sidebars and menus. The following section explains each area of the Photoshop screen and how to retrieve it if it disappears.

THE SCREEN LAYOUT FOR PHOTOSHOP

Photoshop's main screen can look cluttered and confusing at first. Whether you've opened an image in the program or just opened the program, there will probably be a menu across the top, a toolbar down the left side of the screen, a number of boxes down the right side and maybe some additional toolbar buttons and options across the top of the screen. The screen displayed on page 25 is labelled with the following numbered elements, which make up the typical main screen.

Photoshop CS5 on the PC

1. **Menu bar**: Use the mouse to click on a menu option listed here and a menu will drop down with various choices to select. Alternatively, press the Alt key on the keyboard to activate the menu bar and one letter will be underlined for each menu option. Press that letter on the keyboard to see the respective menu drop down.

2. **Useful toolbar buttons**: These toolbar buttons can zoom in and out of an image, open Adobe Bridge and Mini Bridge (helps to locate files), switch to full-screen mode and arrange multiple images on screen.

3. **Select a workspace**: Click on one of these options to help determine the type of image you are working with. The boxes displayed down the right side of the screen may change,

depending on what you choose. Some of these features may differ, depending on whether you have Photoshop or Photoshop Extended.

4. **CS Live**: Depending on your Photoshop package, you may have a number of links to online material and services, which can be accessed through this drop-down menu.

5. **Minimize, maximize and close buttons**: These are the standard PC buttons for reducing the Photoshop screen, filling it to the full size of the screen and closing the program.

6. **Panels**: A number of different panels can be displayed down the right side of the screen to help with editing an image, creating new layers and undoing actions. These panels can be moved, removed and re-opened via the Window menu.

7. **Options bar**: This toolbar changes, depending on what has been selected. It provides further options for a feature or tool that is in use. For example, if you are cropping an image, the Options toolbar provides settings for cropping to a specific width, height and resolution.

8. **File tab**: Each image that is open is displayed along this area of the screen in a separate tab. Click on the tab to display the image and click on the X-shaped button to the right of each tab to close an image.

9. **Tools toolbar**: These are some of the most useful tools for editing and creating images. Hover the mouse pointer over a button and a description of it may appear next to the mouse pointer, or look at the Info panel on the right side of the screen (click on the Window menu and choose Info). Right click on a toolbar button to see a number of different options for it.

Hot Tip

Not sure which version of Photoshop is installed? Click on the Help menu and choose About Photoshop. A message box will appear displaying the version of Photoshop.

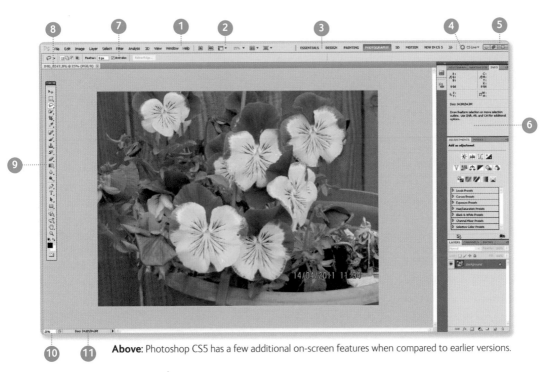

Above: Photoshop CS5 has a few additional on-screen features when compared to earlier versions.

10. **Zoom control**: A value as a percentage displays the size of the image on screen. Click on this number and change it to zoom in and out of the image. If the image has not been maximized, then the zoom control is displayed at the bottom of its window.

11. **Image information**: Click on the triangle to see a list of different categories of information. For instance, select Document Dimensions to see the width, height and pixels per inch for the image on screen. If the image has not been maximized, then the information is displayed at the bottom of its window.

Older Versions of Photoshop CS

The main screen in older versions of Photoshop is very similar to the latest CS5, with the exception of some of the features along the top of the screen being omitted. Also, the method of closing an image is slightly different if it has been maximized. There will be two X-shaped

buttons in the top-right corner of the screen. Click on the lower X-shaped button to close the image.

ON THE APPLE MAC

The Photoshop screen for the Mac has most of the features outlined in the annotated image of Photoshop CS5 for the PC. The major differences are the maximize, minimize and close buttons in the top-right corner of the screen, which, on the Mac, are displayed on the lefthand side of an image in Standard Screen Mode (so you cannot close the whole program with these buttons, just the image). *Note:* the Command key on a Mac (the 'apple' or the '⌘' key) is the equivalent of a PC's Ctrl key; while, because a Mac's mouse only has one button, the Ctrl key is used to 'right click' (though system preferences can be used to set up a 'right click' on laptop trackpads and mice such as Apple's Mighty Mouse).

Above: The main screen in earlier versions of Photoshop CS is similar to the latest version.

Above: Photoshop on the Apple Mac has the same menus, toolbars and panels as on the PC.

MISSING TOOLBARS AND PANELS

Most toolbar buttons and panels can be retrieved by clicking on the Window menu and re-selecting them from the list that appears. You may not know the name of the panel you are looking for, so you may need to select and de-select in trial and error until you learn them.

Moving Toolbars and Panels

Most toolbars and panels on the Photoshop screen can be moved by dragging and dropping them. This can become frustrating, especially if you can't move it back or accidentally close it. However, all toolbars and panels can be retrieved via the Window menu.

OPENING, SAVING AND CLOSING

Photoshop is similar to most programs when it comes to opening, saving, resaving and closing images. The following section outlines how to quickly open Photoshop and any images you want to edit and save as other file types or with a different name.

OPENING PHOTOSHOP

Photoshop can be opened in a variety of ways, depending on the setup of your computer and whether particular files are associated with this program. The following list outlines the common methods:

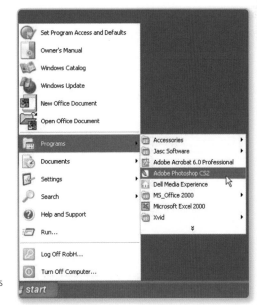

→ **Taskbar or Dock**: If an icon for Photoshop is displayed along the bottom of the screen, click on this to open the program.

→ **Start menu**: Windows-based PCs (such as Windows XP or Windows 7) may have Photoshop listed on the Start menu under Programs. After clicking on the Start menu in the bottom-left corner of the screen, choose Programs and look for Adobe Photoshop. If it is not listed, look for Adobe and a sub-menu should appear with Photoshop listed.

Right: Photoshop can be opened on most Windows-based PCs via the Start menu in the bottom-left corner of the screen.

- **On-screen shortcut**: If a Photoshop icon is displayed on the screen, then single or double click on it to open the program.

- **Open an image file**: Some image files are linked (file association) to Photoshop, so, when you double click on the file, Photoshop will open automatically. For further details on this, see the next section on linking a file to Photoshop.

- **Drag an image (Mac)**: Drag an image file on to the Photoshop icon to open it in Photoshop.

- **Right or Ctrl click**: Right click on an image file using a Windows-based PC, or Control and click with a Mac. From the menu that appears, choose to open or edit the file with Photoshop (if listed).

Hot Tip

Windows PC: If your keyboard has a Windows symbol key on the bottom left, hold this down and press E on the keyboard to open Windows Explorer and look for files.

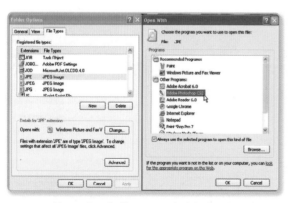

Above: Specific file types can be linked to Photoshop so they are automatically opened in the program.

LINKING A FILE IN WINDOWS TO PHOTOSHOP

A particular file type (for example, all JPEG image files) can be linked or associated with Photoshop, so, when you double click on such a file, it automatically opens in Photoshop. To do this, open My Computer, Windows Explorer or Document Library, click on the Tools menu and choose Folder Options. From the dialogue box that appears, select the File Types tab and

an alphabetically sorted list will appear. Locate and select the file type you want (for example, JPG or JPEG). Click on the Change button and a second dialogue box will appear with some programs listed. Select Adobe Photoshop and click on OK in both boxes.

OPENING AN IMAGE WITHIN PHOTOSHOP

If Photoshop is already open, there are various methods for opening an image file. The following list outlines some of the popular methods:

- **Ctrl+O (PC)**: Hold down the Ctrl key on the keyboard and press the letter O. An Open dialogue box will appear, allowing you to locate and open a file.

- **Command+O (Mac)**: Hold down the Command key on the keyboard and press the letter O. An Open dialogue box will appear, allowing you to locate and open a file.

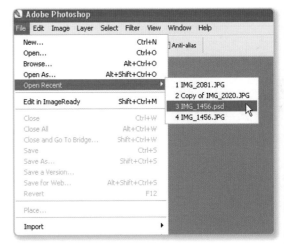

- **File menu**: Click on the File menu and choose Open. An Open dialogue box will appear, allowing you to locate and open a file.

Above: Photoshop lists the recently opened files so they are easier to find if you have forgotten the name of one of them.

- **Recent files**: Click on the File menu and choose Open Recent. A sub-menu will appear, listing the most recently opened files.

- **Drag and drop**: Providing Photoshop is already open, a file can be dragged and dropped into the program to open and edit it.

SAVING A FILE IN PHOTOSHOP

There are a number of techniques for saving a file in Photoshop, which are as follows:

→ **Ctrl+S (PC)**: Hold down the Ctrl key on the keyboard and press S to instantly save a file. If the file has not been saved before, a Save As dialogue box will appear, allowing you to name the file and choose a location to save it.

→ **Command+S (Mac)**: Hold down the Command key on the keyboard and press S to instantly save a file. If the file has not been saved before, a Save As dialogue box will appear, allowing you to name the file and choose a location to save it.

→ **File menu**: Click on the File menu and choose Save to instantly save the file. If the file has already been saved and has not changed, then this option will not be available.

Saving a File with Another Name, Type or Location

If you want to change the name of a file, save it as a different file type (such as TIFF or JPEG) or change where it is saved, then click on the File menu and choose Save As. From the dialogue box that appears, you can enter a new name for the file, change the file type and choose a different location to store it.

Hot Tip

PC: Hold down the Ctrl and Shift keys, then press S to open the Save As dialogue box to rename the file and change the file type and location it is saved to.

Above: The Save As dialogue box allows the name, type and location of a file to be changed.

FILE TYPES IN PHOTOSHOP

There are a wide variety of different file types that can be opened and saved in Photoshop. Many of these types are defined near the beginning of this chapter (see pages 19–22). If you are unsure whether a particular file type can be opened in Photoshop, use one of the methods of opening a file and see if Photoshop can open it. If Photoshop cannot open it, a message box will appear, often with an explanation as to why the file could not be opened. Similarly, if you want to save a file as a particular type, follow the instructions on saving a file with another name, type or location and see if the required file type is listed.

CLOSING FILES IN PHOTOSHOP

There are a number of controls in Photoshop to help close individual files or all the files that are open in Photoshop. The following list outlines some of the quick and useful techniques:

File menu: Click on the File menu and choose Close to close the file that is open and active on the screen, or Close All to close all files that are open within Photoshop. The program will remain open.

Ctrl+W (PC): Hold down the Ctrl key on the keyboard and press W to close the file that is currently open and active in Photoshop.

Above: If a number of files are open in Photoshop, they can all be closed together by clicking on File and choosing Close All.

Hot Tip

Mac: Hold down the Command and Shift keys, then press S to open the Save As dialogue box to rename the file and change the file type and location it is saved to.

➔ **Command+W (Mac)**: Hold down the Command key on the keyboard and press W to close the file that is currently open and active in Photoshop.

➔ **Ctrl+Alt+W (PC)**: Hold down the Ctrl and Alt keys on the keyboard and press W to close all the files that are open in Photoshop. This action will not close Photoshop.

➔ **Command+Alt+W (Mac)**: Hold down the Command and Alt keys on the keyboard and press W to close all the files that are open in Photoshop. This action will not close Photoshop.

➔ **Windows 7**: Left click on the Photoshop icon at the bottom of the screen and a list of open files will appear. Click on the X-shaped button next to each file to close it.

CLOSING PHOTOSHOP

Photoshop can be quickly closed along with any files that are open. The following list reveals some of the fastest and popular methods of closing the program:

➔ **Alt+F4 (PC)**: Hold down the Alt key on the keyboard and press F4 for most Windows-based PCs. Photoshop and any files that are open will close.

➔ **Right click on the Taskbar (PC)**: If Photoshop is displayed on the taskbar along the bottom of the screen, right click on it and choose Close.

➔ **Command+Q (Mac)**: Hold down the Command key on the keyboard and press Q to close Photoshop.

Hot Tip

Upon closing Photoshop, if a file has not been saved, then a message box will appear asking if you want to save its changes.

IMAGE INFORMATION

It is often important to know specific information about an image, such as its size and resolution, to ensure it can be printed or displayed in a particular format. It may also be useful to know the camera settings for a photograph to check its quality.

HOW BIG IS AN IMAGE?

The file size of an image in kilobytes (KB) or megabytes (MB) does not always help determine the actual size of an image in terms of how it will look when printed as a poster, for example, or whether it will be too big to display on a web page. The best way to check the size of an image is to find its width and height, plus its dots or pixels per inch (DPI or PPI). With the file open in Photoshop, click on the Image menu and choose Image Size. From the dialogue box that appears, the width, height and resolution (pixels per inch) will be displayed.

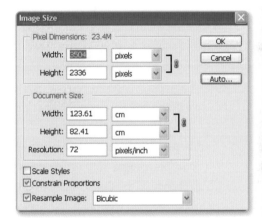

Above: The width, height and pixels per inch of an image can all help to determine whether an image is large enough to print on to a poster or small enough to display on a web page.

What is the PPI?

The pixels per inch (PPI) of an image is useful to know, especially if an image is going to be printed or displayed on a website. This is sometimes referred to as dots per inch (DPI). For example, if an image is going to be printed, the PPI may have to be set at 300, which is the quality setting for most printers. If an image is going to be displayed on a website, most

Hot Tip

PC: Hold down the Alt and Ctrl keys on the keyboard, then press the letter I to open the Image Size dialogue box.

images are set at 96 PPI. The meaning of PPI and DPI is given on page 19, under Photoshop Jargon. Changing the number of pixels per inch of an image is covered on page 36).

> ## Hot Tip
> **Most cameras have different quality settings for taking photographs, which are sometimes represented as 2M for 2 megapixels or 3M for 3 megapixels.**

Calculating Megapixels

The quality of photographs taken by most cameras is usually measured in megapixels (millions of pixels). When viewing the Image Size dialogue box, especially for a photograph, the pixels for the width and height of the image will be displayed. If these values are multiplied together, then the resulting figure represents the number of megapixels for the image. For example, our illustration for the Image Size dialogue box (page 33) shows a width of 3,504 pixels and a height of 2,336 pixels. Multiply these values together and the result is 8,185,344 – just over 8 million pixels or 8 megapixels.

Megapixels in File Viewers

Some file viewers, such as Windows Explorer, list the dimensions of an image (you may need to change to the Details view) as pixels for the width and height. If multiplied together, the resulting figure represents the number of megapixels for an image.

Name ▲	Size	Type	Date Modified	Date Picture Taken	Dimensions
Copy of IMG_2081	2,579 KB	JPEG Image	30/09/2010 13:36	30/09/2010 13:36	3504 x 2336
Copy of IMG_2095	626 KB	JPEG Image	30/09/2010 22:45		2944 x 1724
IMG_2071	2,185 KB	JPEG Image	30/09/2010 13:34	30/09/2010 13:34	3504 x 2336
IMG_2072	2,226 KB	JPEG Image	30/09/2010 13:34	30/09/2010 13:34	3504 x 2336
IMG_2074	2,404 KB	JPEG Image	30/09/2010 13:36	30/09/2010 13:36	3504 x 2336
IMG_2081	2,579 KB	JPEG Image	30/09/2010 13:36	30/09/2010 13:36	3504 x 2336
IMG_2086	2,600 KB	JPEG Image	30/09/2010 13:37	30/09/2010 13:37	3504 x 2336
IMG_2088	2,487 KB	JPEG Image	30/09/2010 13:37	30/09/2010 13:37	3504 x 2336
IMG_2093	2,554 KB	JPEG Image	30/09/2010 13:37	30/09/2010 13:37	3504 x 2336
IMG_2101	2,696 KB	JPEG Image	30/09/2010 13:40	30/09/2010 13:40	3504 x 2336
SmallTr1ke	21 KB	JPEG Image	03/12/2010 09:27		432 x 288

Above: Files listed in Windows Explorer and other file viewers often display the file size, which does not help to indicate the quality of the image in terms of pixels, dimensions or DPI. However, the dimensions listed on the far-right column can be multiplied together to calculate the quality of an image.

View Image Information on Screen

Image information can be displayed near the bottom-left edge of the Photoshop screen. Click on the triangle on this bottom edge and, from the menu that appears, choose Show. Select Document Dimensions from the sub-menu and the menu will close. Information concerning the width, height and dots or pixels per inch (DPI or PPI) will be displayed along the bottom edge of the Photoshop screen.

SEE THE CAMERA SETTINGS FOR A PHOTOGRAPH

With a photograph open in Photoshop, click on the File menu and choose File Info. From the dialogue box that appears, select Camera Data 1 from the list on the left or the tabs along the top and some information will be displayed concerning the make and model of camera used to take the photograph, the date the photograph was taken and settings including shutter speed, aperture (F-stop), ISO speed rating, lens data and whether the flash was used. Select other categories listed on the left to see details concerning the owner of the photograph (click on IPTC Contact) and any notes.

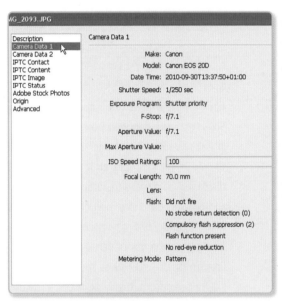

Above: Photoshop can often display camera settings for a photograph, including shutter speed, aperture, lens details and film speed. This is useful information for checking the quality of a photograph.

Hot Tip

PC: Hold down the Ctrl, Alt and Shift keys on the keyboard, then press the letter I to open the File Information dialogue box.

EASY ALTERATIONS

Photoshop can perform some complicated changes to help alter and improve the quality of an image. However, first it is essential to know how to quickly perform the most popular alterations, such as resizing, cropping and rotating.

CHANGING THE SIZE OF AN IMAGE

Click on the Image menu and choose Image Size. From the dialogue box that appears, alter the width, height and resolution values to suit. If, for example, an image needs to be displayed on a website, change the resolution to 96 pixels per inch, then change the width and height accordingly. Make sure a tick mark is added to the option labelled Constrain Proportions. This ensures the width and height are automatically adjusted in relation to each other.

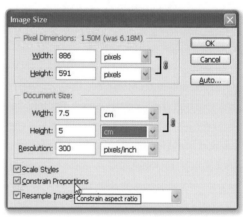

Above: An image's width, height and pixels per inch can be altered using the Image Size dialogue box.

Resize a Photo for a Passport

If a photo or an image needs to be a certain size to ensure it can be trimmed to a particular width and height when printed, Photoshop can usually do this using the Image Size dialogue box. Just make sure the resolution in pixels per inch is correctly set,

Hot Tip

If you have used any drop shadows or embossed text in an image, tick the option labelled Scale Styles when resizing an image. This will help to resize these features.

then adjust the width and height accordingly. In some cases, the image will need to be cropped, which is covered in the next section.

CROPPING AN IMAGE

Areas of an image can be excluded using the cropping tool. This is like taking a pair of scissors to a photograph and trimming off one or more edges. However, Photoshop is better than a pair of scissors because it can crop to specific dimensions.

Hot Tip

Press C to switch on the Crop Tool, or Shift and C to switch between that and other tools on the same button.

Quick Cropping

Click on the Crop Tool on the Tools toolbar down the left side of the screen. The button looks like a square with extended edges. If a pen tool is displayed instead, right click (PC) or Ctrl and click (Mac) on it and choose Crop Tool. Next, move the mouse pointer into the image to be cropped and draw a box to represent the new edges of the image. Double click inside the drawn box to crop the image.

Above: The crop tool is on the toolbar displayed down the left side of the screen. It looks like a square with extended edges.

Re-draw or Extend

After drawing a box with the crop tool, if the dimensions are wrong or the drawn box is too small or too large, then you can do one of the following:

- Press Escape on the keyboard and the crop box will disappear. You can now start again and draw a new box to crop the image.

- Position the mouse pointer over the edges or corners of the drawn box and it will change to a double-headed arrow. Hold the left button down on the mouse and move the mouse pointer to resize the drawn box.

Move the Cropped Area

After drawing a box with the crop tool, the box can be moved to cover and crop a different part of the image. Position the mouse pointer inside the drawn box, hold the left button down and move the mouse to move the drawn box. To complete cropping, double click inside the cropped area.

Rotate and Crop

Once a box has been drawn with the crop tool, position the mouse pointer on the outside corners of it. If you are too close to a corner, the mouse pointer will look like a double-headed arrow, but, as you move away from the corner, the mouse pointer will eventually change to a semi-circular double-headed arrow. When this happens, hold the button down on the mouse

Above: A cropped area can be rotated prior to finally cropping it.

(left button for a PC mouse) and move it to rotate the cropped area of the image. Release the mouse button to stop rotating, then double click inside the cropped area to complete the cropping of the image.

Cropping to Specific Dimensions

If an image has to be cropped to a specific width and height (for example, for a passport photo or to fit on to a website), then select the crop tool and look at the Options bar across the top of the screen. Enter values for the width, height and resolution. In later versions of Photoshop, there is a drop-down list of typical crop sizes to choose from (click on the crop button in the far-left corner of the Options bar). After choosing the dimensions for cropping, draw a box over the image and it will be automatically sized to suit.

Hot Tip

Can't see the Options bar across the top of the screen? Click on the Window menu and choose Options.

ROTATING AND FLIPPING IMAGES

Images can be quickly rotated in Photoshop, which is particularly useful for photographs taken as a portrait but stored as a landscape. Similarly, images that are not perfectly straight can be straightened using the rotate tools, and flipping an image can help to rearrange it.

Changing from Portrait to Landscape

Click on the Image menu, choose Image Rotation or Rotate Canvas and, from the sub-menu that appears, select either 90°CW (clockwise) or 90°CCW (counterclockwise).

Straightening a Photograph or Image

If an image or photograph needs to be marginally tilted to straighten it, click on the Image menu, select Image Rotation or Rotate Canvas and choose Arbitrary from the sub-menu. A small Rotate Canvas box will appear on the screen. Enter a value in the Angle box and choose whether to rotate counterclockwise (CCW) or clockwise (CW), then click on OK. You may need to repeat this a few times. Afterwards, you may want to crop the image (see the previous section).

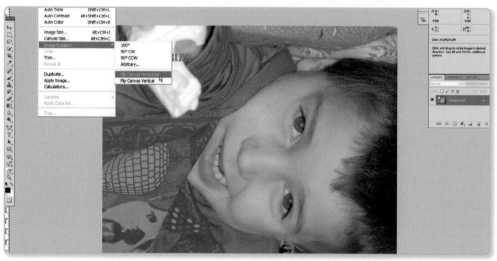

Above: An image can be rotated and flipped by clicking on the Image menu and choosing Image Rotation.

Horizontal and Vertical Flipping and Rotating

Sometimes, an image looks better if it is rotated 180 degrees, or swapped around (flipped). This is all possible in Photoshop, using the following menu commands:

→ **Flip**: Click on the Image menu, select Image Rotation or Rotate Canvas and choose Flip Canvas Horizontal or Flip Canvas Vertical. This method will change the image so that any text is displayed back to front (as though you are looking at it in a mirror).

→ **Rotate 180 degrees**: Click on the Image menu, select Image Rotation or Rotate Canvas and choose 180°. The image will be rotated by half a turn.

Hot Tip

If you rotate an image the wrong way, press Ctrl and Z (PC) or Command and Z (Mac) on the keyboard to undo the action.

MAGIC WAND AND QUICK SELECTION TOOLS

Selecting specific areas and objects in an image is essential to be able to edit, delete, re-colour and copy parts of it. The Magic Wand and Quick Selection tools are quick to use and provide effective methods for selecting parts of an image.

WHERE IS THE MAGIC WAND?

The Magic Wand is on the Tools toolbar, which is usually displayed down the left side of the screen. In later versions of Photoshop CS, the Magic Wand shares the same toolbar button as the Quick Selection Tool, so it may need to be chosen from this button. This can be done by any of the following:

Above: The Magic Wand is displayed on the Tools toolbar. In later versions of Photoshop, you may need to select it from the Quick Selection Tool.

⊖ **Right click (PC):** Right click on the button for the Magic Wand and Quick Selection tools and a menu will appear. Select Magic Wand from the menu.

⊖ **Ctrl and click (Mac):** Hold down the Ctrl key on the keyboard and click on the button for the Magic Wand and Quick Selection tools and a menu will appear. Select Magic Wand from the menu.

⊖ **Hold the button down:** Position the mouse pointer over the button for the Magic Wand and Quick Selection tools, hold the mouse button (left button on the PC) down for a few seconds and a menu will appear. Select Magic Wand from the menu.

Above: The Magic Wand and Quick Selection tools provide fast and simple selection methods of objects inside an image.

Above: The Magic Wand selects part of an image according to the colour that has been clicked on.

SELECTING A COLOUR WITH THE MAGIC WAND

After selecting the Magic Wand, the mouse pointer will change shape. Move the now wand-shaped mouse pointer over the part of the image you want to select and click with the mouse. The colour the mouse is hovering over at the point of clicking will be selected. The selection is represented by a series of moving dotted lines. In some cases, anything else in the image with the same colour will also be selected.

Selecting More of the Same Colour with the Magic Wand

If other areas in an image need to be selected, hold down the Shift key on the keyboard, or click on the Add to Selection toolbar button near the top left of the screen and select them using the mouse. Upon holding down the Shift key or clicking on the Add to Selection toolbar button, a plus symbol will appear next to the mouse pointer.

UNSELECTING WITH THE MAGIC WAND

If part of an image has been wrongly selected with the Magic Wand, it can be quickly unselected without having to start again. The following methods can be used to remove part of a selection:

Hot Tip

Press W on the keyboard to switch on the Magic Wand.

- **Alt key (PC and Mac)**: Hold down the Alt key on the keyboard and a minus symbol will appear next to the mouse pointer. Use the mouse to click on an unwanted selection and the dotted lines will disappear from it.

- **Subtract from Selection toolbar button**: Click on the Subtract from Selection toolbar button on the Options bar (across the top left of the screen) and a minus symbol will appear next to the mouse pointer. Use the mouse to click on an unwanted selection and the dotted lines will disappear from it.

TOOLBAR BUTTONS VERSUS KEYBOARD

If you click on the toolbar buttons for Add to Selection and Subtract from Selection, these features will be permanently switched on and you will need to choose something else (for example, New Selection) to switch them off. If instead you use the keyboard controls, these features are switched off the moment you release the relevant key on the keyboard.

FINE TUNING THE MAGIC WAND

The Options bar displayed along the top left of the screen (underneath the menus for File, Edit, Image) has some settings for altering the way Photoshop uses the Magic Wand. The most useful is the Tolerance setting. The number displayed in the box next to Tolerance can be changed. If a larger number is entered, a greater variance of colours is selected (for example, light to dark orange). A smaller number reduces the variance.

Above: The Tolerance setting for the Magic Wand allows a greater or narrower range of colours to be selected.

Hot Tip

Press Ctrl and D (PC) or Command and D (Mac) to unselect everything.

QUICK SELECTION TOOL

Photoshop CS3 and later versions have a Quick Selection Tool, which is useful for selecting objects in an image. This tool works with shapes and differentiates them according to the colour of an object and the colour of its background. The Quick Selection Tool is on the Tools toolbar on the left side of the screen and is on the same toolbar button as the Magic Wand. If the Magic Wand is displayed, then the following instructions can be followed to change it to the Quick Selection Tool:

Hot Tip

Press Shift and W to switch between the Quick Selection Tool and Magic Wand.

➔ **Right click (PC):** Right click on the button for the Magic Wand and a menu will appear. Select Quick Selection Tool from the menu.

➔ **Ctrl and click (Mac):** Hold down the Ctrl key on the keyboard, click on the button for the Magic Wand and a menu will appear. Select Quick Selection Tool from the menu.

➔ **Hold the button down:** On both Mac and PC, position the mouse pointer over the button for the Magic Wand, hold the mouse button down (left button on the PC) for a few seconds and a menu will appear. Select Quick Selection Tool from the menu.

Above: The Quick Selection Tool shares the same toolbar button as the Magic Wand.

SELECTING AN AREA WITH THE QUICK SELECTION TOOL

With the Quick Selection Tool switched on, move the mouse pointer into the area of the image to be selected, hold the mouse down (left button on a PC) and drag the mouse pointer over the area (a series of dotted lines will appear around the selection). The Quick Selection Tool will automatically expand its selection and try to estimate what needs to be selected. Release the mouse button to stop selecting.

Above: The Quick Selection Tool is useful for selecting objects in an image by dragging the mouse over them.

Selecting More with the Quick Selection Tool

Look at the top left corner of the screen for the Options bar (underneath the menus). There are a series of buttons that look like the Quick Selection toolbar button. One of them has a plus symbol (+) attached to it. If this button is highlighted, then more areas within the image can be selected by swiping over them using the mouse. If this toolbar button is not highlighted, click on it and you can select more areas within the image to add to the selection.

Hot Tip

Hold down the Shift key on the keyboard and continue using the Quick Selection Tool to add to a selection.

UNSELECTING WITH THE QUICK SELECTION TOOL

Select the toolbar button in the top-left corner of the screen, which looks like the Quick Selection Tool but has a minus symbol (-) above it. Alternatively, hold down the Alt key on the keyboard and a minus symbol will appear above the mouse pointer. In both cases, hold the mouse button down and move over a selected area to unselect it. Release the Alt or Option key on the keyboard to stop unselecting, or, if you clicked on a toolbar button, choose another button to switch off unselecting.

FINE-TUNING THE QUICK SELECTION TOOL

The size of the Quick Selection Tool can be changed, which helps to select small or large areas of an image. The size of this tool is displayed in the Options bar across the top-left corner of the screen. Look for a toolbar button with a dot, number and drop-down triangle. Click on the drop-down triangle and a number of options will appear. Change the size or diameter setting to alter the size of the Quick Selection Tool.

Above: The size of the Quick Selection Tool can be altered to help select detailed areas of an image or large objects.

Hot Tip

Press Ctrl and Z (PC) or Command and Z (Mac) on the keyboard to undo the previous action. This can be useful if you have wrongly selected something.

SELECTING WITH A LASSO

The Lasso tools are useful for selecting part of an image. It is similar to drawing around an object to select it and has a number of methods to help do this more easily. The following pages show where to find the Lasso tools and how to use them.

LASSO TOOL TYPES

In most versions of Photoshop, there are three different types of Lasso tool, which are as follows:

- **Standard Lasso**: This is a freehand tool, which requires a steady hand to carefully click around an object to draw a selection around it.

Above: The Lasso Tool is a popular method for selecting part of an image and has three variations.

- **Polygonal Lasso**: Straight lines are drawn between every click of the mouse, which allows a selection to be drawn around part of an image.

- **Magnetic Lasso**: Based on colour, the Magnetic Lasso follows the path of the mouse pointer and adds selection points with a line. This is the quickest of the Lasso tools, providing the part of the image you want to select is a different colour.

CHOOSE A LASSO TOOL

The three different types of Lasso tool can be selected from the toolbar button on the left side of the screen as follows:

Above: The Magnetic Lasso automatically adds fastening points around a selection, based on colour differences.

→ **Right click (PC)**: Right click on the button for the Lasso Tool and a menu will appear. Select one of the Lasso tools from the menu.

→ **Ctrl and click (Mac)**: Hold down the Ctrl key on the keyboard, click on the button for the Lasso Tool and a menu will appear. Select one of the Lasso tools from the menu.

Hot Tip

Press L on the keyboard to switch on the Lasso Tool and Shift and L to switch between the different types.

→ **Hold the button down**: Position the mouse pointer over the button for the Lasso Tool, hold the mouse button (left button on the PC) down for a few seconds and a menu will appear. Select one of the Lasso tools from the menu.

Above: Click around an object using the Polygonal or Magnetic Lasso tool to select it.

SELECT AN OBJECT WITH THE LASSO

After selecting one of the Lasso tools from the Tools toolbar on the left side of the screen, position the mouse pointer over the part of the image where you want to start selecting. If you are using the standard Lasso Tool, hold the mouse button down (the left mouse button for a PC) and move the mouse to draw around the part of the image you want to select. If you are using the Polygonal or Magnetic Lasso, click the mouse button to start the Lasso Tool, then move the mouse pointer to draw around the part of the image to select it. Click whenever necessary to add fastening points around the selection (the Magnetic Lasso will also add selection or fastening points automatically).

Finish Selecting
There are two methods for completing a selection when using the Lasso Tool. These are as follows:

➔ **Double click**: Double click with the mouse button and the Lasso will automatically complete the selection, returning to the starting point.

➔ **Return to the start**: Continue selecting until the mouse pointer returns to the starting point of the selection. When a small circle appears next to the mouse pointer, click once to complete the selection. If the small circle does not appear, double click to complete the selection.

Select More with the Lasso

After selecting part of an image using the Lasso Tool, you may find there are more parts of the image that need to be selected. If this is the case, either click on the Add to Selection button on the Options bar (across the top of the screen) or hold the Shift key down on the keyboard. In both cases, select another area of the image to add to the selection. Any previously selected parts will not be lost.

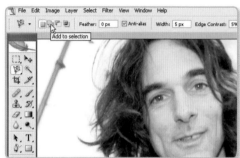

Above: After selecting part of an image using one of the Lasso tools, click on the Add to Selection button to add to this selection.

Unselect with the Lasso

It is easy to select unwanted areas of an image, as the Lasso Tool can unselect as well as select. Either click on the Subtract from Selection button on the Options bar (across the top left of the screen) or hold down the Alt key on the keyboard. In both cases, a minus symbol will appear next to the mouse pointer. Select an area that has already been selected and it will be unselected.

COMBINE THE LASSO TOOLS

Part of an image can be selected using a combination of Lasso tools. For example, you can

> ## Hot Tip
> Press the Tab key on the keyboard to show or hide the toolbars and panels and provide more space on the screen when selecting.

initially select part of an image using the Magnetic Lasso, then switch to the Polygonal Lasso to select any bits that have been missed and finish off with the standard Lasso to remove any small unwanted selections.

FINE-TUNE THE LASSO

The Lasso Tool has a number of settings, which can help with selecting part of an image. When the Lasso Tool is selected from the toolbar down the left side of the screen, its settings are displayed in the Options bar across the top left of the screen. The following explains the most useful settings that can be altered:

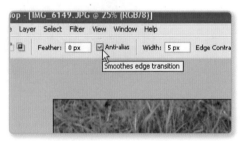

Above: The Lasso tools can be fine tuned to ensure edges of the selection are smooth and fastening points are sufficiently frequent.

Anti-aliasing: This tick box helps to smooth any jagged edges of a selection by softening the colours between the edge pixels and the background pixels. Only the edge pixels change, so no detail is lost.

Feather: Useful if you are going to move, cut, copy, or fill the selection. It blurs or smudges the edges of the selection. This can cause some loss of detail along the edge of the selection.

Contrast (Magnetic Lasso): Represents the Magnetic Lasso's sensitivity to edges in the image with values between 1% and 100%. A higher percentage only detects edges that contrast sharply with their surroundings.

Frequency (Magnetic Lasso): The rate at which the Magnetic Lasso sets automatic fastening points when making a selection. Values range from 0 to 100, where a higher value produces more fastening points.

Refine Edge: A dialogue box will appear with the selected part of the image displayed.

SHAPE SELECTION

A selection can be created in the form of a shape, such as a rectangle, square, circle or ellipse. The following pages explain how this is achieved in Photoshop using the Marquee tools.

SELECTION BY SHAPES

The Marquee tools are used to make geometric selections within images, which can be useful for creating photographs with colour for the selection and black and white for the remainder of the image. The Marquee tools can make selections in the shape of rectangles, squares, circles, ellipses and single rows and columns. All of these selection tools can be found on the toolbar button on the left side of the screen, near the top. There are a number of different ways of choosing a particular type of Marquee tool:

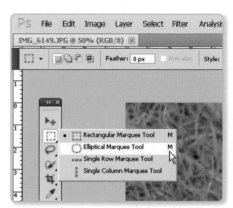

Above: The Marquee tools include a number of geometric selection methods.

Right click (PC): Right click on the button for the Marquee Tool and a menu will appear. Select one of the Marquee tools from the menu.

Ctrl and click (Mac): Hold down the Ctrl key on the keyboard, click on the button for the Marquee Tool and a menu will appear. Select one of the Marquee tools from the menu.

Hold the button down: Position the mouse pointer over the button for the Marquee Tool, hold the mouse button (left button on a PC mouse) down for a few seconds and a menu will appear. Select one of the Marquee tools from the menu.

Creating a Marquee Selection

After selecting a specific type of Marquee Tool, move the mouse pointer into the image, hold the mouse button down (the left button for a PC mouse) and move the mouse to draw the shape of the selection over the image. Release the mouse button to stop drawing the selection. The selection will be represented by a dotted line.

Selecting from the Centre

Whilst the Marquee Tool for selecting a rectangle or ellipse is usually created from corner to corner, hold down the Alt key before starting the selection and the centre of the rectangle or ellipse will start wherever the mouse pointer is positioned. This only works when creating one selection because the Alt key has another function, which is discussed later in this section (*see* page 53).

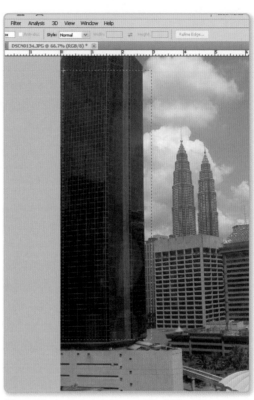

Above: The Rectangular Marquee is useful for selecting a building, as shown in this photograph.

Creating a Square or Circle

Hold down the Shift key when selecting a rectangle or ellipse with the Marquee Tool and a square or circle will be created. This only works when creating one selection because the Shift key has another function, which is discussed in the next section.

Hot Tip

Activate the Marquee Tool by pressing M on the keyboard, then switch between the different ones by pressing Shift and M.

Selecting More Objects with the Marquee Tool

More areas of an image can be selected and included in current selections. After making a selection, hold down the Shift key and select another part of the image. This can overlap an existing selection and the two will be joined together. Aside from using the keyboard to add to a selection, there is also a toolbar button along the Options bar (across the top left of the screen), which can also be used (it is called 'Add to selection').

Removing Part of a Selection

Part of a selection can be removed by holding down the Alt key and selecting it using one of the Marquee tools. If you don't want to use the keyboard, click on the 'Subtract from selection' button on the Options bar (across the top left of the screen). This method of removing part of a selection enables different shaped selections to be made, such as a cross from a square or a semicircle from a circle.

Above: Multiple shapes can form selections using the Marquee Tool. In this example, the duck has been selected using two ellipses.

Hot Tip

All selections in an image can be removed by clicking on the Select menu and choosing Deselect.

PENS AND PATHS

Drawing a path is considered to be one of the most accurate methods for creating a selection. The following pages show how to use this tool in Photoshop and convert it to a selection.

SELECTING USING THE PEN TOOL

The Pen Tool allows a path to be plotted and drawn on the screen, then finely altered by moving, adding and deleting points along the path. This method is different to creating a selection with a Magic Wand, Quick Selection, Lasso or Marquee, because initially a selection is not created. Instead, a path is created, which needs to be converted into a selection to manipulate it.

Select the Pen Tool

The Pen Tool is usually halfway down the Tools toolbar on the left side of the screen. There are a number of Pen Tool buttons, so the follow one of these steps in order to choose the correct one:

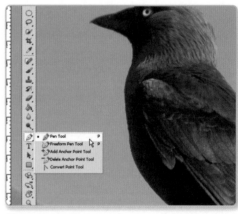

Above: The Pen Tool is used to draw a path, before turning it into a selection.

- **Right click (PC):** Right click on the button for the Pen Tool and a menu will appear. Select Pen Tool from the menu.

- **Ctrl and click (Mac):** Hold down the Ctrl key on the keyboard, click on

Hot Tip

Press P on the keyboard to switch on the Pen Tool.

the button for the Pen Tool and a menu will appear. Select Pen Tool from
the menu.

⊙ **Hold the button down**: Position the mouse pointer over the button for the
Pen Tool, hold the mouse button (left button on the PC) down for a few seconds
and a menu will appear. Select Pen Tool from the menu.

Draw a Path

After selecting the Pen Tool, move the mouse pointer to the edge of the part of the image
you want to select and click once to add an anchor point and start using the Pen Tool. Move
along the edge of the part of the image you want to select and click to add more anchor
points, which are joined together by a line. When you return to the starting point, a circle
will appear next to the mouse pointer – click once and the selection will be completed.

Adjust the Path

After drawing a path around part of an image, it will probably need to be adjusted to make
sure the selection is accurate. Right click (PC) or Ctrl and click (Mac) on the Pen Tool and
choose the Add Anchor Point Tool. Click on the edges of the path (the line for the selection) to
add more points. Each point can be dragged to move it and change the shape of the selection.

Zoom In to Adjust the Path

It usually helps to zoom into parts of the path to
see how accurate the selection is. Press Ctrl (PC),
or Command (Mac), and '+' on the keyboard to
zoom in and Ctrl/Command and '–' to zoom out.
Upon zooming in, use the scroll bars to move
around the image and press the Tab key to
remove the toolbars and panels for a less
cluttered screen (press the Tab key again and
they will reappear).

Hot Tip

A path and parts of it can
be removed from the screen
by pressing Delete on
the keyboard.

Delete Anchor Points and the Path

Right click (PC) or Ctrl and click (Mac) on an anchor point and choose Delete Anchor Point to remove it. If you want to remove the entire path, right click or Ctrl and click on any part of it and choose Delete Path.

Convert a Path to a Selection

Once a path has been created, it helps to convert it to a selection so it can be further manipulated. Right click (PC) or Ctrl and click (Mac) inside the image and choose Make Selection. A small dialogue box will appear with some settings for adjusting the feathering and edges of the selection.

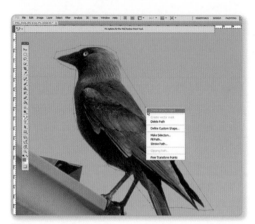

Above: An anchor point can be deleted by right clicking on it. Similarly, the entire path can be removed by right clicking on it.

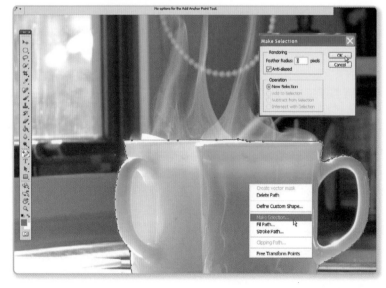

Left: After creating a path around part of an image, it can be converted into a selection and edited.

SAVING A SELECTION

Once a selection has been created using the Lasso, Magic Wand, Marquee or any selection tool, it is beneficial to save it in case it becomes unselected or you need to re-use it at a later date. The following shows how to save a selection with an image and open it again in the future.

SAVING A SELECTION

With the selection still on the screen, click on the Select menu and choose Save Selection. From the dialogue box that appears, enter a name for the selection and click on OK. The file must be saved as a Photoshop PSD file to allow the selection to be re-opened.

Reusing a Selection

Open a file that contains a saved selection, click on the Select menu and choose Load Selection. From the dialogue box that appears, click on the drop-down triangle for Channel and choose the selection that was saved with this file. Click on OK and the selection will appear on screen.

Using a Selection with Another Image

If you have several photographs which are all the same, you may want to select the same area in each one and edit it. In this case, select the relevant area in one image, save it and the file as a Photoshop PSD, then open the other images and load the selection into them.

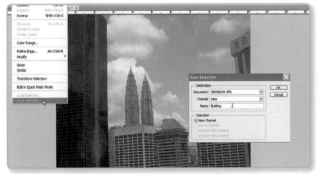

Above: A selection can be saved as a Photoshop PSD file and re-opened at a later date.

CUT, COPY, PASTE

The traditional methods for cutting, copying and pasting can be applied to Photoshop, just like most other computer programs. The following section outlines the quick methods for using these tools and contains a step-by-step guide to selecting and copying part of an image and pasting it into another photograph.

CUT, COPY AND PASTE CONTROLS

There are a number of keyboard and menu controls for activating cut, copy and paste in Photoshop, which are similar to other programs. The following list outlines the popular techniques:

Hot Tip

Text from another program can be copied and pasted as an object into an image in Photoshop.

Left: A selected part of an image can be cut or copied via the Edit menu.

➔ **Ctrl key (PC)**: Hold down the Ctrl key on the keyboard and press C to copy, X to cut and V to paste.

➔ **Command key (Mac)**: Hold down the Command key on the keyboard and press C to copy, X to cut and V to paste.

➔ **Edit menu**: Click on the Edit menu and choose Cut, Copy or Paste.

LAYERS AND PASTING

Photoshop works in a slightly different way to other programs where text, images or data is cut or copied, then pasted. Most programs store objects and information that has been cut or copied on a clipboard, whereas Photoshop has a similar approach but creates layers for anything that has been pasted. The subject of layers needs to be understood and is covered in depth in the next section of this chapter.

STEP BY STEP

The following step-by-step guide shows how to select a jackdaw from a photograph, copy it, then paste it into another photograph. The image files used are called Jackdaw.jpg and Mugs.jpg, which are available to download via Flame Tree Publishing's website at www.flametreepublishing.com/samples.

1. Using Photoshop, open the image files called Jackdaw.jpg and Mugs.jpg. Click on the Window menu and select Jackdaw.jpg to make sure it is on the screen. If necessary, maximize this image to the full size of the screen (click on the maximize box near the top right of the image).

2. We are going to select the jackdaw, then copy it and paste it into the Mugs.jpg image. Move the mouse pointer up to the top-left corner of the screen and look for the Lasso

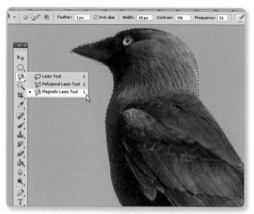

Above: Use the Magnetic Lasso to select the outline of the jackdaw.

button on the toolbar down the left side of the screen (it is usually the third button from the top). When you've found it, right click (PC) or Ctrl and click (Mac) on this button and choose Magnetic Lasso.

3. Look across the top of the screen at the Options bar and a setting called Frequency. This determines the number of fastening or anchor points when using the Magnetic Lasso. Change the number to 50 (100 is the maximum amount).

4. Move the mouse pointer into the image of the jackdaw and position it on the tip of the bird's beak. Click once with the mouse to start the Magnetic Lasso, then move the mouse pointer around the edge of the bird to select it. Keep clicking to make sure the Magnetic Lasso is selecting the edges of the bird.

5. Move around the entire outer edge of the bird (don't worry about the blue sky between the legs, it will be removed in step 6) and back to the tip of the beak, then double click with the mouse to complete the selection.

6. If any parts of the jackdaw are missing from the selection, hold the Shift key down on the keyboard and select them using the same technique outlined in step 4. If there are any unwanted bits of blue sky in the selection, hold down the Alt key and unselect them using the same technique outlined in step 4.

Hot Tip

After copying a selection, it can be pasted several times into another image.

7. Once you are satisfied the jackdaw has been correctly selected, click on the Edit menu and choose Copy. Next, click on the Window menu and choose Mugs.jpg. Click on the Edit menu again and choose Paste. The jackdaw will appear in the Mugs.jpg image.

8. The pasted jackdaw can be moved by selecting the toolbar button near the top left of the screen, which looks like a cross and a triangle pointing upwards (the Move button). After selecting it, position the mouse pointer over the pasted jackdaw, hold the button down (left button for a PC mouse) and move the mouse to move the jackdaw.

9. When you've finished moving the jackdaw, the image needs to be flattened to be able to save it. Click on the Layer menu and choose Flatten Image. You can then click on the File menu and choose Save As to save the image with a new name, or select Save to store the Mugs.jpg image with the jackdaw.

Above: The copied jackdaw can be pasted into another image via the Edit menu.

Above: Multiple jackdaws can be pasted into this image. Before saving the edited photograph, flatten the image first.

Hot Tip

Press V on the keyboard to switch on the Move tool.

UNDERSTANDING LAYERS

The use of layers is a technical subject within Photoshop that requires a thorough understanding to be able to edit and create images effectively. The following section provides a beginner's guide to layers and explains how and when they should be used.

WHAT IS A LAYER?

Parts of an image in Photoshop can be selected to enable these parts to be edited (colours changed, resized, copied), so a dull sky in a landscape photograph can be made brighter, for example. Similarly, artwork can be divided into separate pieces of text, drawings and photographs, so they can be moved around, changed and copied. Photoshop can do this by making a layer from each part. This method makes it easier to choose parts of the image and edit them.

Above: The jackdaw selected in the photograph on the left can be pasted several times into the photograph on the right. Each pasted image is a separate layer, which can be moved and edited on its own.

HOW IS A LAYER CREATED?

A layer can be created in a number of ways. The following list outlines some of the popular methods:

⊝ **Copy and paste:** If all or part of an image is selected, copied and then pasted into another image, a new layer is automatically created upon pasting. In the previous section, the step-by-step guide shows how to select a jackdaw,

copy it, then paste it into another image. Each time the jackdaw is pasted, it appears as a new layer and is displayed in the Layers panel on the right side of the screen.

↪ **Layer menu**: The Layer menu in the top middle of the screen has a number of options. You can choose a new layer of a whole image (Duplicate Layer), a blank layer (Background from Layer), a layer from copying (Layer via Copy) and several other choices. Click on the Layer menu and select New to see these options on a sub-menu.

↪ **Layers panel**: One of the panels on the right side of the screen should have a Layers tab. If this is not visible, click on the Window menu and choose Layers to see this panel. From within this panel, new layers can be created and existing layers selected and organized.

STEP BY STEP

The following step-by-step guide shows how to select part of an image, create a layer from it, then add it to another image. The files used are available via Flame Tree Publishing's website at www.flametreepublishing.com/samples.

1. Open the image file called Jackdaw.jpg and, using the Magnetic Lasso, select the outline of the jackdaw (see pages 59–60 in the previous section for a step-by-step guide on using the Magnetic Lasso).

2. After selecting the jackdaw, click on the Layer menu, choose New and select Layer via Copy from the sub-menu. The dotted lines around the selected bird will disappear, but look at the Layers panel on the right side of the screen: there should be an additional layer with the bird inside it.

Above: After selecting the jackdaw, the bird can be copied into a new layer, which can be used in other images. Notice the new layer, containing just the bird, on the right side of the screen.

3. Open the image file called Mugs.jpg, then click on the Window menu, choose Arrange and select Tile or Tile Vertically. The Jackdaw.jpg and Mugs.jpg images should be displayed side by side on the screen. Click inside the jackdaw image, then look at the Layers panel on the right. Drag and drop the cutout jackdaw from the Layers panel into the Mugs.jpg image. A cutout Jackdaw will appear.

 Hot Tip

 A layer can be quickly removed by selecting it from the Layer panel on the right side of the screen and pressing Delete on the keyboard.

4. Several more jackdaws can be added to the Mugs.jpg image by repeating the procedure in step 3. Alternatively, right click or Ctrl and click on the name of the layer in the Layers panel on the right and choose Duplicate Layer. From the dialogue box that appears, choose a name for the new layer and click on OK. This can be repeated several times to add more jackdaws to the Mugs.jpg image.

5. Each layer can be moved by selecting one of them from the Layers panel on the right side of the screen, then dragging and dropping the respective layer around inside the image (make sure the Move Tool is selected – press V to switch it on). If you want to return and continue editing this image, save it as a Photoshop PSD file. When you have finished editing it, click on the Layer menu and choose Flatten Image, then save the image as a JPG file.

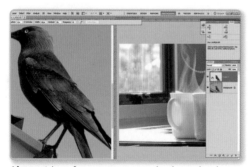

Above: A layer from one image can be dragged and dropped into another image.

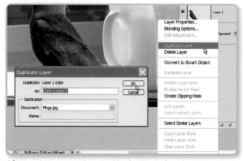

Above: Layers can be quickly duplicated in the Layers panel by right clicking on their respective names.

CHANGING THE LOOK OF A LAYER

A selected layer can be shrunk, enlarged, rotated or flipped. Just select the layer from the Layers panel on the right, then click on the Edit menu, choose Transform and, from the sub-menu that appears, select any of the following:

- **Scale**: Useful for changing the size of the layer. A box appears around the layer; hover over the edges or corners and, when the mouse pointer changes to a double-headed arrow, drag it to resize the layer.

- **Rotate**: Manually rotates the layer in a similar manner to scaling (see above). The sub-menu can also rotate the layer by 180 degrees and 90 degrees clockwise and counterclockwise.

- **Skew**, **Distort**, **Perspective and Warp**: Adjusts the angles of the image in a variety of different ways. Uses similar methods to the scale method.

- **Flip**: Useful for swapping a layer around, so, for example, the jackdaw is looking to the right instead of the left.

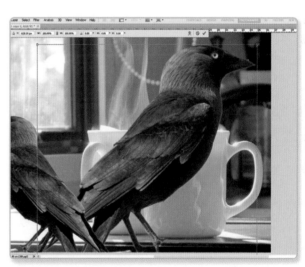

Above: Each layer can be resized, rotated and flipped by selecting it, then clicking on the Edit menu and choosing Transform.

Hot Tip

After transforming a layer by flipping, rotating and performing other alterations, press Enter/Return to complete the changes, or Escape to reject them.

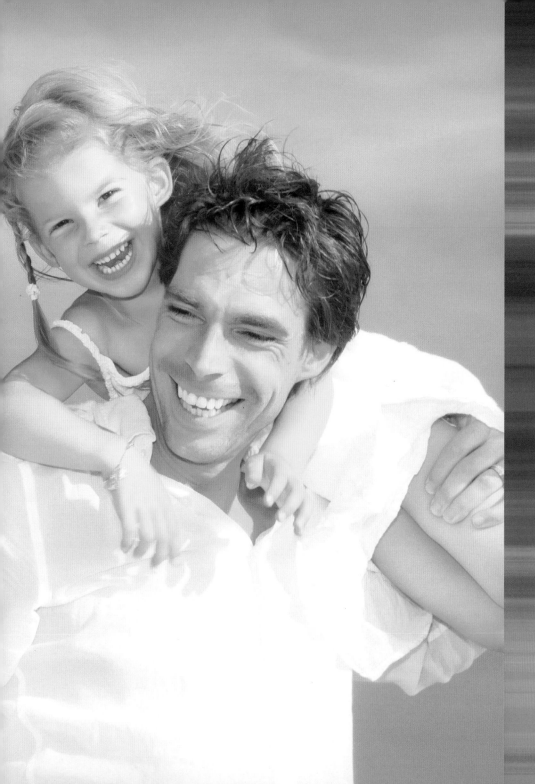

IMPROVING AN IMAGE

BRIGHTENING A DULL SKY

Scenic and landscape photographs are often taken with dull, cloudy skies, but luckily there are a number of methods for either brightening the sky or changing it to blue. The following section shows what you can do.

BRIGHTENING A DULL SKY

If a sky is full of dull, dark clouds, or the camera hasn't correctly exposed them and they appear darker than they should be, Photoshop can help. The following list explains what is involved:

➔ **Select the sky**: Use one of the selection methods outlined in the previous chapter to select the sky. If the sky is a different colour from the rest of the photograph, then the Magnetic Lasso, Magic Wand and Quick Selection tools can be used. Otherwise, the Polygonal Lasso Tool is useful for selecting the sky, or, if you want to be particularly accurate, use the Pen Tool.

Above: A dull sky can often be selected using the Magnetic Lasso, providing it is a different colour to the landscape.

Above: Adjusting the brightness and contrast of the selected sky has changed it from being dull and dark.

◉ **Save the selection**: Once the sky has been selected, it is worth saving it, just in case you need it again in the future. Click on the Select menu and choose Save Selection – enter a name for the selection and click on OK.

◉ **Brighten the sky**: Make sure the sky is still selected. Click on the Image menu, choose Adjustments and select Brightness/Contrast from the sub-menu. From the dialogue box that appears, adjust the brightness and contrast settings to alter the sky (make sure Preview is ticked to see the changes).

◉ **Save the image as a Photoshop PSD**: If you want to return to the image and use the saved selection again, make sure the file is saved as a Photoshop PSD. This will ensure the saved selection is stored with the file. The selection can be recalled by clicking on the Select menu and choosing Load Selection.

Hot Tip

If you want to use the image illustrated on the left to practise, download the file called CloudyHills.jpg from Flame Tree Publishing's website at www.flametreepublishing.com/samples.

CHANGE A SKY FROM CLOUDY TO BLUE

The sky in a landscape or scenic photograph can be completely changed, for example, from cloudy to bright blue. To do this, you will need a photograph with a cloudy sky and one with a blue sky. Such images can be found on Flame Tree Publishing's website at www.flametreepublishing.com/samples and are called CloudyMountains.jpg and BlueSky.jpg. The following step-by-step guide explains how to change the sky in the CloudyMountains.jpg file to the blue sky from the BlueSky.jpg file.

Above: A cloudy sky can be changed to bright blue by firstly selecting the landscape and making it into a separate layer from the sky.

Above: The layer of the landscape can be dragged into an image with a blue sky.

Hot Tip

Press C on the keyboard to switch on the Crop Tool.

STEP BY STEP

1. Using CloudyMountains.jpg, select the land and tops of the mountains using the Magnetic Lasso and Polygonal Lasso tools. Use the Polygonal Lasso to select the majority of the land, then hold the Shift key down on the keyboard and use the Magnetic Lasso to add the top edge of the mountain.

2. After selecting the land and tops of the mountains, create a layer from this selection by clicking on the Layer menu, choosing New and selecting Layer via Copy. Look at the Layers panel on the right side of the screen and a new layer of the selected ground will have been created.

3. Open the file called BlueSky.jpg. Click on the Window menu, choose Arrange and select Tile or Tile Vertical. Make sure you can see both images, then select CloudyMountains.jpg. The Layers panel will show the copied layer of the landscape created in the previous step. Drag and drop it into the BlueSky.jpg image.

4. With the landscape from the CloudyMountains.jpg image copied into the BlueSky.jpg image, move the ground

to make sure there is only blue sky at the top of the image (don't worry about the bottom of the image yet). The CloudyMountains.jpg file can now be closed (save it as a Photoshop PSD file if you want to use it and its layer again).

5. When the landscape from the CloudyMountains.jpg image is in the correct position, click on the Layer menu and select Flatten Image. Finally, crop the image by selecting the Crop button from the toolbar on the left side of the screen. Cropping was covered in chapter one (see pages 37–39).

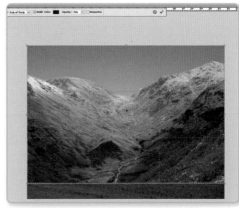

Above: Once the landscape has been dropped into its new background, it has to be flattened before it can be cropped.

Further Adjustments

The two examples outlined (brightening a dull sky and changing a sky from cloudy to blue) can be further modified to make them even more realistic. The following list outlines some of the Photoshop techniques that can help:

Hot Tip

Press F7 to switch the Layers panel on and off.

- **Feathering**: Before using any of the selection tools, check the value for feathering in the Options bar across the top of the screen. This can help to make sure the edge of the mountains don't look rough and jagged.

- **Contrast**: If you use the Magnetic Lasso to select the top edge of a hill or mountain, check the Contrast setting in the Options bar across the top of the screen. This may need to be adjusted to help reduce the risk of selecting the sky.

- **Combine selection tools**: Don't rely on one selection tool. Use a combination of them to speed up selection. Methods of selecting are fully explained in chapter one.

FIXING A BRIGHT OR DARK PHOTOGRAPH

If a photograph is too bright or too dark, Photoshop may be able to improve its quality. Even if just part of the photograph is too bright or too dark, Photoshop can usually come to the rescue.

Above: The photograph displayed in the bottom left looks too dark. Photoshop can improve this image by increasing both the brightness and contrast, as shown in the larger photograph.

ALTER BRIGHTNESS AND CONTRAST

The first step in fixing a photograph that looks too bright or too dark is to alter the brightness and contrast. Click on the Image menu, choose Adjustments and select Brightness/Contrast from the sub-menu. A small dialogue box will appear with slider controls for brightness and contrast. Drag these slider controls and the brightness and contrast will automatically change on the image (make sure the box for Preview is ticked). Click on OK to apply the changes and return to the image, or click on Cancel to reject the changes.

Adjusting Part of an Image

In many cases, only part of an image may need to be adjusted if it is too dark or too bright. Consequently, the part of the image that needs to be adjusted has to be selected first. This is covered in depth in chapter one, using selection tools including the Magnetic Lasso, Magic Wand and Marquee. Once the selection has been made, return to the Brightness and Contrast dialogue box and adjust the controls.

USING LEVELS TO ADJUST THE BRIGHTNESS

Using Levels allows the black, white and grey colours in an image to be selected to ensure they are correctly displayed. This feature also enables an image to be made lighter or darker. Click on the Image menu, select Adjustments and choose Levels. From the dialogue box that appears, click on the Auto button to see if Photoshop can instantly improve the image. In many cases it can and you won't need to do anything else. Otherwise, the sliders for the Input Levels and Output Levels can be adjusted to change the range of light and dark colours. This is best understood by adjusting the sliders and seeing what happens to the image (make sure Preview is ticked).

Hot Tip

A cloudy sky is often best adjusted by reducing the brightness and increasing the contrast.

Choosing Blacks, Whites and Greys with Levels

Make sure the Levels dialogue box is open, then look for the three small buttons that resemble a set of droppers or pipettes. The far right button chooses a white point in the image, the far left button chooses a black point and the middle button selects a mid-grey point. Click on each button in turn and select a point in the image where, respectively, a white, black and mid-grey point exists. You don't always need to click on all three buttons to do this and may find the image is better after using just one of them.

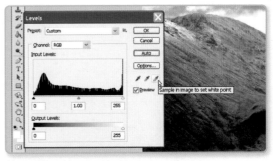

Above: The white cloud in this photograph can be selected to set the white point in the image and in turn adjust the rest of it.

Hot Tip

Press Ctrl and L on a PC or Command and L on a Mac to open the Levels dialogue box.

COLOUR ADJUSTMENTS

If an image looks washed out, too yellow from fluorescent lighting or in need of some fill-in flash, then Photoshop can often rescue the picture and help transform it.

AUTO ADJUSTMENTS

One of the quickest methods of adjusting the look of an image to improve it is to use the auto adjustments for colour, tone and contrast. Depending on the version of Photoshop, these can either be found on the Image menu under Auto Tone, Auto Contrast and Auto Color, or by clicking on the Image menu, selecting Adjustments and choosing them from the sub-menu that appears. Early versions of Photoshop do not have all three options. In all cases, adjustments are automatically made and can be reversed by clicking on the Edit menu and choosing one of the Undo options.

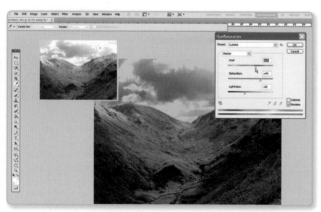

Above: The grass in the original image near the top-left corner seems dull, but can be made greener by increasing the Hue and Saturation.

HUE AND SATURATION ADJUSTMENTS

Adjusting the hue and saturation of an image helps to alter the colouring, the depth of the colours and the darkness/lightness of them. Click on the Image menu, choose Adjustments and select Hue and Saturation from the sub-menu. A Hue and Saturation dialogue box will appear. Try the following adjustments:

- **Hue**: The slider for Hue starts at red on the left and moves through the colours of the rainbow to violet on the right. Adjust the slider and see what happens to the image (make sure the Preview box is ticked). Grass, for example, will become greener if the slider is two thirds to the right.

- **Saturation**: This is the strength of the colours. Adjust the slider to see where colours become stronger and weaker.

- **Lightness**: After adjusting the hue and saturation, the image may need to be made darker or lighter to get the most from the colour alterations.

USING FILTERS TO ADJUST COLOURS

Photographers will often use a variety of filters attached to the front of the lens to help warm up an image, create a sunset or reduce glare. Most of these can be reproduced in Photoshop by clicking on the Image menu, choosing Adjustments and selecting Photo Filter. From the dialogue box that appears, select a filter from the drop-down list, make sure the Preview box is ticked and see if the image is altered. Adjust the Density slider to increase or decrease the intensity of the filter used.

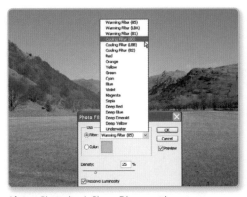

Above: Photoshop's Photo Filter provides a selection of filter effects used in photography, plus a full range of colours.

Apply a Colour Filter

Photoshop has a number of colour filters, which can be useful for increasing the red in a sunset, for example. The drop-down list in the Photo Filter dialogue box has a selection of colours. Alternatively,

Hot Tip

Press Ctrl and U (PC) or Command and U (Mac) to open the Hue and Saturation dialogue box.

select the Color option, then click inside the colour that is displayed and a second dialogue box will appear with a choice of colours. Select a colour from the vertical scale in the middle of the dialogue box, then choose a contrast for that colour from the larger box on the left. Click on OK to return to the Photo Filter dialogue box.

Hot Tip

A photograph taken on a sunny winter's day may look yellow, but can often be improved by using a warming filter.

Filter a Selection

If only the sky in a photograph needs to be changed using a filter, then select it first. Selecting part of an image was covered in chapter one, using tools including the Magnetic Lasso, Magic Wand and Marquee. Once the selection has been made, return to the Photo Filter dialogue box and choose a suitable filter or colour for the selection.

Removing a Yellow Fluorescent Lighting Cast

When a photograph is taken under artificial lighting, especially fluorescent or halogen lighting, the camera may not automatically adjust the white balance, so the image looks very yellow.

This can be quickly fixed in Photoshop by bringing up the Photo Filter dialogue box and choosing one of the Cooling Filters from the drop-down list. Adjust the density to find a suitable strength for the filter, then click on OK.

Left: The smaller original image on the left looks too yellow, caused by artificial lighting when the photograph was taken. By applying a cooling filter and adjusting the density, the yellow cast has been removed.

DODGING, BURNING AND SPONGING

The traditional photographic printing tricks of over- and underexposing parts of an image are known as dodging, burning and sponging. These can be recreated in Photoshop, but are much quicker and just as useful for helping to fix dull and bright areas of a photograph.

DODGE, BURN AND SPONGE DEFINED

Above: The Dodge Tool can be used to remove dark shadows, which often appear around people's eyes when a photograph is taken in bright sunlight or if they are wearing a hat.

↪ **Dodge**: An area of an image is underexposed to reduce its brightness. This is useful where a sky is too bright or a photograph is taken indoors and the window is too bright. In the traditional days of printing photographs in a darkroom, dodging involved using a thin piece of metal with a piece of paper on the end to block the light when exposing the print.

↪ **Burn**: Intensifying the exposure over part of an image that appears too dark or underexposed. This is useful for dark shadows, particularly under the eyes when taking a photograph in bright sunlight. Burning in a darkroom used to involve overexposing part of a photographic print using a piece of card with a hole cut out of it.

↪ **Sponge**: Increases the intensity or saturation of colours in an area of an image or increases/decreases the contrast of a black and white image. Sponging in a darkroom

was done when the print was being developed in a tray of developing chemicals. If it looked washed out, a sponge with fresh developing chemicals could be rubbed across it to help increase the exposure.

Where Are the Dodge, Burn and Sponge Tools?

If you've never used the Dodge, Burn and Sponge tools before, look for the Dodge Tool on the Tools toolbar down the left side of the screen. It looks like a large dark lollipop. When you've found it, click on the button and hold the mouse button down (left mouse button for a PC) until a menu appears with all the tools listed (Dodge, Burn and Sponge). Select one from this list.

Above: The Burn Tool adjusted to a hardness of 30–50% can help to darken the clouds in this landscape photograph.

Using the Dodge, Burn and Sponge Tools

After selecting one of the Dodge, Burn or Sponge tools, look at the Options bar across the top-left of the screen and change any settings for exposure, range and the size and hardness of the tool. These settings are important to ensure the tools are effective. Next, position the mouse pointer (it should be a circle) over the part of the image you want to dodge, burn or sponge. Hold the mouse button down (left mouse button for a PC) and move across the part of the image to dodge, burn or sponge. If nothing happens, change the settings in the Options bar and try again.

CORRECTING WIDE-ANGLE DISTORTION

When a photograph is taken with a wide-angle lens, upright objects such as buildings are sometimes not as straight as they should be. Photoshop can fix this problem and straighten them using the Transform tools.

SELECT AND TRANSFORM

There are a variety of methods for straightening a distorted part of an image, but the starting point in most cases is to select the part of the image that is distorted and needs straightening. The various methods of selecting part of an image are covered in depth in chapter one, including tools such as the Magnetic Lasso, Magic Wand and Polygonal Lasso. Once the object has been selected, it can then be adjusted to straighten it and remove its distortion.

Transform – Rotate

After selecting a distorted part of an image, such as a building that doesn't look straight, click on the Edit menu, choose Transform and select Rotate. A box and series of squares will appear around the selection. Position the mouse pointer on the outside corner of this box and a small semicircle-shaped arrow will appear next to it. When this happens, hold the mouse button down (left mouse button for a PC) and move the mouse to rotate the selection and straighten the distorted object.

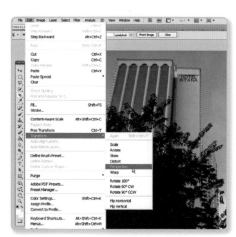

Above: This building does not look straight because the photograph was taken using a wide-angle lens. By selecting it and using the Transform's Perspective Tool, it can be straightened.

Hot Tip

Combine selection tools to accurately select part of an image.

Above: The selected building can be rotated and its perspective altered to straighten its appearance. The selection then needs to be moved and the image cropped to finish editing.

Transform – Perspective

Another Transform feature is the Perspective adjustment, which is on the same sub-menu as Rotate (see previous section for details). This adjusts a selection in the same manner as rotating it, but is sometimes more effective when attempting to straighten a distorted-looking building.

Move the Selection

After rotating or adjusting the perspective of a selection using one of the Transform tools, there may be a gap in the image. The selection can now be moved to help fill the gap. Position the mouse pointer inside the middle of the selection, hold the mouse button down (left button for a PC) and move the mouse to move the selection.

Switch off Transform

When you've finished using one of the Transform tools (such as Rotate or Perspective), the changes can be rejected by pressing Escape on the keyboard, or accepted by pressing Return or Enter. The adjusted image may need to be cropped, so switch on the Crop tool by pressing C on the keyboard, then draw a box for the new shape and size of the image, double click inside it and it will be automatically cropped (*see* chapter one, pages 37–39 for more information on cropping).

Hot Tip

When one of the Transform tools is being used, the selection can be moved using the arrow keys on the keyboard.

SHARPEN AN IMAGE

The focusing of a photograph can be improved in Photoshop to make it look sharper, plus part of an image can be kept in focus whilst the rest of the image is blurred to make it stand out.

SHARPEN UP

A photograph can be sharpened to make it look brighter and crisper. In some cases, this will make the image look too grainy, but in many situations it helps to improve the image. With the image open in Photoshop, click on the Filter menu, select Sharpen and, from the sub-menu that appears, choose Sharpen and see if the image changes. If it doesn't, return to the Sharpen sub-menu and choose Sharpen More (also try choosing Sharpen Edges). If this doesn't help, return again to the Sharpen sub-menu and choose Unsharp Mask. From the dialogue box that appears, carefully adjust the sliders to see if the image can be improved (keep the Radius value to no more than 2.0).

Above: An image can be made to look crisper and clearer using Sharpen, Sharpen More, Sharpen Edges and Unsharp Mask.

Hot Tip

The Unsharp Mask can make an image too grainy, so make careful adjustments and keep an original copy of the image you are adjusting.

BLUR THE BACKGROUND

One method of making a subject or group of subjects stand out is to make the background out of focus or blurred. It helps to emphasize a subject and is used in a variety of images ranging from portraits and text to photographs of food and buildings. This effect can usually be achieved with a camera, using a wide aperture to achieve a narrow depth of field (often easier with a long or telephoto lens), but Photoshop can replicate this setup.

Select the Background

The first step in blurring the background in a photograph is to select it using one of the selection tools (Magic Wand, Magnetic Lasso, Rectangular Marquee). These selection tools are covered in chapter one. It may be easier to select the object that needs to remain in focus, then click on the Select menu and choose Inverse to reverse the selection and choose the background instead.

Apply a Gaussian Blur

With the background or subjects that need to be out of focus selected, click on the Filter menu, choose Blur and select Gaussian Blur. From the small dialogue box that appears, alter the

value for Radius and look at the image (make sure the Preview box is ticked). Do not adjust the Radius too high as the blurred selection won't look effective. Click on OK to accept the adjustment and return to the image.

Above: The Gaussian Blur effect is useful for making a background out of focus, but do not overdo it on the Radius value.

Hot Tip

Switch off a selection by pressing Ctrl and D (PC) or Command and D (Mac) on the keyboard.

QUICK IMAGE EDITING

When you haven't got much time to alter an image and improve it, there are some fast techniques in Photoshop that can quickly fix a photograph or image and make it look a lot better in a matter of seconds.

AUTO OPTIONS

Click on the Image menu and choose Auto Tone, Auto Contrast and Auto Color to instantly adjust these settings. In earlier versions of Photoshop, these are available on the Adjustments sub-menu on the Image menu.

VARIATIONS

Click on the Image menu, select Adjustments and choose Variations from the sub-menu. A large window will appear with a variety of samples of the image that is currently open and selected in Photoshop. Each sample will be slightly different as it contains different colour adjustments. There are more choices by choosing between Shadows, Midtones, Highlights and Saturation at the top of the window. If one of the samples looks better than the current image, select it and click on OK.

Above: The Variations window provides a number of colour-adjusted examples of an image, allowing a better image to be quickly selected.

BRIDGE AND MINI BRIDGE

Photoshop's Bridge and Mini Bridge are useful for finding images and editing them before opening them in Photoshop. Bridge acts as a separate program, which allows you to browse for images, whereas Mini Bridge looks as though it's part of Photoshop. The two features can be opened via the File menu. In early versions of Photoshop, select Browse from the File menu for Bridge to open (Mini Bridge is not available in early versions) and in later versions select Browse in Bridge or Browse in Mini Bridge.

Above: Mini Bridge is available in later versions of Photoshop and allows images to be found and quickly edited using the Camera Raw program.

> # Hot Tip
>
> **Press Ctrl, Alt and O on the PC to open Bridge (or Alt, Command and O on the Mac).**

Editing an Image from Bridge and Mini Bridge

Both Bridge and Mini Bridge act as a file viewer to help find images. Each image can be displayed as a thumbnail, renamed and rotated, and then opened in Photoshop. In later versions of Photoshop, the image can be quickly edited in another program called Camera Raw, which allows the brightness, contrast and other settings to be changed.

EQUALIZE AN IMAGE

Photoshop's Equalize command redistributes the brightness of an image. It will find the brightest and darkest values in the image or a selected area and make the necessary adjustments so the brightest parts are white and the darkest parts are black. Click on the Image menu, select Adjustments and choose Equalize from the bottom of the sub-menu.

Equalize a Selection

If part of an image is selected using one of the selection tools (Magnetic Lasso, Magic Wand), then a dialogue box will appear upon choosing Equalize, allowing you to equalize the selected area only, or equalize the entire image based on what is in the selected area.

SOFTENING AN IMAGE

Portrait and wedding photographers often use a soft filter to warm up the image and create a hazy photograph. A similar technique can be recreated in Photoshop to turn normal family photographs into professional-looking images. The following step-by-step guide shows how to do this.

STEP BY STEP

1. With a photograph open in Photoshop, the first stage in creating a hazy-looking image is to make a duplicate layer. This will be used to merge a hazy version of the image with the original image. Click on the Layer menu and choose Duplicate Layer. From the dialogue box that appears, click on OK. Notice a new layer has been added to the Layers panel on the right side of the screen.

2. Click on the Filter menu, select Blur and choose Gaussian Blur from the sub-menu. A small dialogue box will appear on the screen. Adjust the Radius value until the image on screen starts to become blurred (make sure the Preview box is ticked). When the image is sufficiently blurred, click on OK.

3. The opacity of the duplicate layer that has been blurred needs to be reduced to allow the

Hot Tip

Press F7 to show or hide the Layers panel on the right side of the screen.
NB: On both Mac and PC, use of the function keys depends on your default system settings.

Above: After creating a duplicate layer, add a Gaussian blur to it and adjust the Radius value. This will create a hazy image.

Above: After adding a Gaussian blur to the duplicate layer, its opacity has to be reduced to allow the original layer to be seen.

original image to show through. This helps to achieve a hazy, soft-focused image. Look at the Layers panel on the right side of the screen. Make sure the duplicate layer is still selected, then reduce the opacity value from 100% (0% will completely remove the hazy duplicate layer).

4. After settling on a specific level of opacity for the hazy-looking duplicate layer, the entire image can be flattened so that it only contains one layer. To do this, click on the Layer menu and choose Flatten Image. The image can now be saved.

Further Reading

Layers: Chapter one covers an introduction to Layers and how they can be used. If you haven't read this section and are wondering what a layer is, please refer to this section first (see pages 62–65). The subject of layers is an essential part of using Photoshop and needs to be understood to use the program effectively.

Special effects: Gaussian Blur is just one of the many special effects that can edit an image and change how it looks. Further special effects are covered in chapter five.

Hot Tip

The Gaussian Blur's settings can be quickly applied again to an image by pressing Ctrl and F on the PC keyboard or Command and F on the Mac.

FIX AN OUT-OF-FOCUS PHOTOGRAPH

A photograph that is slightly out of focus can often be fixed with Photoshop's Unsharp Mask tool. This helps to change the image and make it look clearer and crisper, which often helps to refocus it.

SHARPEN AND SHARPEN MORE

The first stage in attempting to fix a photograph that is slightly out of focus is to use three quick and often effective sharpening techniques. With the photograph open in Photoshop, click on the Filter menu, select Sharpen and look for Sharpen, Sharpen More and Sharpen Edges. First, try selecting Sharpen and see if the photograph's focusing is improved. If it isn't (or it is, but not enough), then return to the sub-menu and choose Sharpen More. Also, try selecting Sharpen Edges.

SMART SHARPEN

Click on the Filter menu, select Sharpen and choose Smart Sharpen from the sub-menu for a dialogue box to appear. This Smart Sharpen dialogue box offers options to rectify the following:

→ **Motion blur**: The subject has moved instead of the camera being out of focus. This can also be applied to camera shake, where the camera has been moved when taking the photograph, resulting in a blurred image.

Above: Photoshop's Smart Sharpen can help to fix a blurred photograph where camera shake has occurred, the lens has not focused correctly or the subject has moved too quickly.

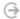 **Lens blur**: The camera hasn't properly focused on the subject, so it appears a little blurred.

The above problems can be addressed via a drop-down list in the Smart Sharpen dialogue box (Gaussian Blur may be listed, but click on a drop-down triangle next to it for further choices).

Advanced Smart Sharpen

Select the Advanced option in the Smart Sharpen dialogue box and three tabs will appear labelled Sharpen, Shadow and Highlight. There are settings under each tab to help improve the photograph. Make sure the Preview box is ticked, then try all the settings to see if any improvements are made.

Above: The out-of-focus photograph on the left can be improved using the Unsharp Mask, although changing the settings can make the picture grainy.

UNSHARP MASK

One of the traditional methods of sharpening a photograph and making it look clearer is to use the Unsharp Mask (despite its name suggesting the opposite). Click on the Filter menu, select Sharpen and choose Unsharp Mask. From the dialogue box that appears, make sure the Preview option is ticked, then carefully alter the Radius value to around 2 pixels. Next, increase the Amount value and see if the photograph looks clearer. Try increasing the Radius value and notice where the photograph starts to lose its quality. If you can't find any improvement, click on Cancel, otherwise click on OK.

Hot Tip

Try selecting part of a photograph that is out of focus, then use the sharpening tools mentioned here. This will help to preserve the rest of the image.

REMOVING DUST AND DIRT MARKS

Dust and dirt on the lens of a camera or inside a camera can spoil a photograph, but are often straightforward to remove using Photoshop. The following section reveals the tools in Photoshop that can remove unwanted objects.

REMOVE DUST DOTS WITH THE SPOT HEALING BRUSH

The Spot Healing Brush is useful for removing dots of dust by blending them in with their surroundings. Its settings can be altered to adjust its size and the intensity of blending. This tool is useful for removing dust and dirt marks that are over people's faces or require delicate Photoshop surgery to remove.

Hot Tip

Switch on the Healing Brush tools by pressing J on the keyboard.

Left: The Healing Brush tools can be found on the Tools toolbar on the left side of the screen.

Where is the Spot Healing Brush?

The Spot Healing Brush is part of a group of Healing Brush tools, which are on the Tools toolbar on the left side of the screen. When you've found the button, it may need to be changed to the Spot Healing Brush by holding the mouse button down when selecting the button (left mouse button on a PC) – a list of different Healing Brushes will appear and you can select the Spot Healing Brush.

Using the Spot Healing Brush

Position the mouse pointer over a dot of dust on a photograph. In most cases, the Spot Healing Brush will have changed the mouse pointer to a circle. Click once with the mouse (left click with a PC mouse) and see if the dust spot has disappeared. If it has, continue clicking on dust spots to remove them.

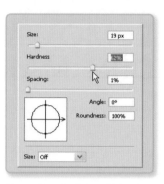

Adjusting the Spot Healing Brush

The Spot Healing Brush can be adjusted by right clicking with the mouse (Ctrl and click for the Mac) when the mouse pointer is inside a photograph. A small box will appear, allowing the size of the Spot Healing Brush, the level of hardness (how much it changes when used) and its shape (useful for delicate alterations) to be changed.

Above: By right clicking (Ctrl and click on the Mac) when the mouse pointer is over the image, the properties of the Spot Healing Brush can be adjusted.

Draw over with the Spot Healing Brush

If several dust marks need to be removed from a sky, for instance, then the Spot Healing Brush can do this very quickly by drawing over them. With the Spot Healing Brush selected, position

the mouse pointer over one of the dust marks, hold the mouse button down (the left button on a PC mouse) and move the mouse to draw a line over all the offending dust marks. Release the mouse button and all the dust marks that have been drawn over will be removed.

Left: Dust marks can be removed at the same time by drawing over them with the Spot Healing Brush.

USING A SAMPLE WITH THE HEALING BRUSH

If dust and other marks need to be removed by copying part of a photograph over them, then Photoshop's Healing Brush can do this. The Healing Brush is on the same toolbar button as the Spot Healing Brush. Once selected, position the mouse pointer over the area of the photograph that needs to be copied, hold down the Alt (or 'Option') key and click once with the mouse (the left button on a PC mouse) to set the area to copy. Next, move the mouse pointer to the area where the dust or other marks exist. Click once with the mouse and the area that was selected will be copied over.

Above: Adjusting further settings for the Healing Brush – such as choosing Replace instead of Normal – can help to make it more effective.

Adjust the Healing Brush

Just like the Spot Healing Brush, the Healing Brush may need to be adjusted to be more effective, so right click inside the photograph (Ctrl and click for the Mac), then change the settings for size, hardness, spacing, angle and roundness. The Options bar across the top of the screen also has a number of settings that can help to adjust the Healing Brush. One particular setting that may prove useful is to change the Mode from Normal to Replace (this produces a more intense Healing Brush for areas that need to be completely changed).

Removing Several Marks with the Healing Brush

Hold the mouse button down when using the Healing Brush and move the mouse to remove several marks. As the mouse pointer is moved, the area that is copied also moves (look for an additional marker on the screen), so make sure you don't copy the wrong area.

APPLYING PATCHES

The Patch Tool can be used to remove dust marks from an area in a photograph. It works in two different ways, depending on what has been selected. First, switch on the Patch Tool by positioning the mouse pointer over the Healing Brush toolbar button (left side of the screen) and holding down the mouse button (left button for the PC) until a short list appears – select Patch Tool from the list. Next, look at the Options bar across the top of the screen and select one of the following:

➔ **Source**: Draw around an area of the photograph containing dust marks. Position the mouse pointer inside the selected area, then drag and

Above: The Patch Tool can be used to select areas of a photograph and remove unwanted dust marks.

Hot Tip

A combination of the Spot Healing Brush and the Healing Brush can effectively remove all unwanted dust marks from a photograph.

Hot Tip

Switch between the Healing Brush tools and Patch Tool by pressing Shift and J on the keyboard.

drop it to a similar part of the photograph that does not contain any dust marks. The dust marks in the selected area will disappear. Release the mouse button to complete the alteration.

Destination: Find an area in the photograph containing dust marks and a similar area containing no dust marks. Draw around the area containing no dust marks, then drag and drop it on to the area with the dust marks. Release the mouse button and the dust marks will disappear.

Continue Patching

When the Patch Tool is set to Destination, continue dragging and dropping the selected area to other parts of the photograph containing dust marks. Each time the selected area is moved to a new part of the photograph, it will remove any dust marks.

Edit the Patch Tool Area

After selecting an area of the photograph with the Patch Tool, this selection can be altered using the keyboard and the mouse. The following list outlines the keyboard keys to use:

Shift and select more: Hold down the Shift key on the keyboard and draw around additional areas of the photograph to add more to the selection. This can be added on to the selection or a separate additional selection created.

Alt to remove: Hold down the Alt key, then draw inside part of a selection to exclude it. This will not damage the photograph, but reduce the selection.

Hot Tip

Press Ctrl and D (PC) or Command and D (Mac) on the keyboard to switch off the selection when using the Patch Tool.

REMOVE AN UNWANTED DATE STAMP

Some digital cameras can include a date stamp with each photograph. If the date stamp needs to be removed, then Photoshop has a number of tools that can help. The following section explains what to do.

CLONE STAMP

Photoshop's Clone Stamp can copy one area of a photograph into another part. This is useful when an object such as a date stamp is in the way and there is an area in the photograph that can be

Hot Tip

Switch on the Clone Stamp by pressing S on the keyboard.

Above: The settings for the size and hardness of the Clone Stamp should be checked before using it.

copied over it. The Clone Stamp is on the Tools toolbar on the left side of the screen. It looks like a large rubber stamp. The Clone Stamp and Pattern Stamp Tool share the same toolbar button. If the Pattern Stamp Tool is selected instead of the Clone Stamp, position the mouse pointer over the toolbar button, hold the button down (the left button for a PC mouse) and wait for a menu to appear. When it appears, select Clone Stamp.

Adjust the Clone Stamp Settings

Before using the Clone Stamp, it is worth checking its settings to make sure it will work effectively. Look along the Options bar across the top left of the screen. Settings for the Clone Stamp will be displayed. Click on the drop-down triangle, which is second from the top left along the Options bar. A small box will drop down, revealing the size of the Clone Stamp and its hardness. The size of the Clone Stamp can be seen by positioning the mouse pointer inside the photograph. Set the hardness to around 50%.

Hot Tip

The Clone Stamp displays the contents of what it will copy inside the mouse pointer, which is displayed as a circle.

Above: When using the Clone Stamp, watch the cross that appears every time you click with the mouse. It shows what it is copying.

Using the Clone Stamp

Position the mouse pointer over an area of the photograph that can be used to copy over the date stamp. This should match the background behind the date stamp. Hold down the Alt (or 'Option') key on the keyboard, then click with the mouse button (left click for a PC mouse). The part of the photograph to copy has now been selected – release the Alt/Option key. Next, move the mouse pointer over the date stamp and click with the mouse. Part of the date stamp will be removed. Continue clicking on the date stamp, but watch what the Clone Stamp is copying (indicated by a cross). You may need to re-select the area to copy.

USING THE SPOT HEALING BRUSH TOOL

In some cases, it may be more effective to use the Spot Healing Brush Tool. This can assess the background behind a date stamp and attempt to copy it over the date. The Spot Healing Brush Tool is part of the Healing Brush tools on the Tools toolbar (left side of the screen and about four or five buttons from the top). Position the mouse pointer over this toolbar button, hold the mouse button down (the left mouse button for a PC) and wait for a list to appear – select Spot Healing Brush Tool.

Adjust the Spot Healing Brush Tool

After selecting the Spot Healing Brush Tool, look along the Options bar across the top left of the screen. Click on the drop-down triangle next to Mode, then select Normal from the list that appears. Position the mouse pointer over the date stamp. The mouse pointer should be a circle. Make sure it is large enough to cover the height of the date stamp. If not, return to the Options bar, click on the second to left drop-down triangle and change the size.

Remove a Date Stamp with the Spot Healing Brush Tool

Once the Spot Healing Brush Tool has been correctly adjusted, see if it can remove the date stamp by clicking on part of it. If this works, try holding the mouse button down (left button for a PC) and swiping across the entire date stamp.

Left: If correctly set up, the Spot Healing Brush can remove a date stamp by swiping the mouse pointer across it with the mouse button held down.

REMOVE RED EYE

Flash photography of people and pets can result in their eyes turning red as a result of the intense light. Fortunately, Photoshop can remove this problem and return their eyes to a normal colour.

FINDING THE RED EYE TOOL

If you have it (*see* page 98 if not), the Red Eye Tool is part of the Healing Brush tools and can be quickly accessed by finding the Healing Brush Tool on the Tools toolbar (left side of the screen), positioning the mouse pointer over it, then holding the mouse button down (left mouse button for a PC) until a list of options appears. Select Red Eye Tool from the list.

Above: Photoshop's Red Eye Tool is part of the Healing Brush buttons on the Tools toolbar.

Adjust the Red Eye Tool

Photoshop's Red Eye Tool's settings may need to be adjusted. After selecting it, look along the Options bar across the top left of the screen (underneath the menu options for File, Edit, Image and Layer). The settings for Pupil Size and Darken Amount may need to be changed if the Red Eye Tool isn't effective.

Using the Red Eye Tool

The Red Eye Tool requires a box to be drawn around an eye where the centre (the pupil) is red. Fortunately, the accuracy of drawing a box is not critical as Photoshop looks for a red colour and converts it to a darker colour.

Consequently, a box can be drawn around the entire eye and Photoshop appears to work. In addition, this procedure can be repeated, so if some red is remaining, just draw another box.

Above: Draw a box around an eye and Photoshop will convert the red pupil to a darker colour.

REMOVE FLASH SPOTS

If the camera's flash has created a white spot in the pupil of the eye of a person or animal, then Photoshop's Red Eye Tool will not remove this. Instead, switch from the Red Eye Tool to the Spot Healing Brush Tool (it is on the same toolbar button), reduce the size to cover the white spot created by the flash and click on it to see if this tool will remove it. It may help to change the settings for this tool (look at the Options bar across the top of the screen), especially the Mode – click on its drop-down triangle and change it from Normal to Replace.

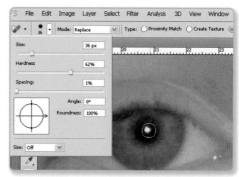

Above: White spots created by a camera's flash are not usually removed by Photoshop's Red Eye Tool, but can be removed using the Spot Healing Brush.

NO RED EYE TOOL?

In early versions of Photoshop CS, the Red Eye Tool is not available, but the Colour Replacement Tool can be used instead. It is located on the left side of the screen and shares its button with the Brush and Pencil Tools (Press B to activate one of these, then Shift and B to switch between them). After selecting it, click on the foreground colour near the bottom of the Tools toolbar (left side of the screen) and choose a suitable eye colour. Change the diameter and hardness of the tool using the controls across the top of the screen, then position the mouse pointer over the red-eye in a photograph and click to replace it with the foreground colour.

REDUCE GLARE AND REFLECTIONS

Bright sunlight can produce glare across objects, resulting in flattened colours or bright spots on glass and chrome. Similarly, reflections in objects can spoil an image. Photoshop can help to remove these problems using a variety of tools.

HEALING BRUSH TOOL

Bright sunspots, glare and unwanted reflections can usually be removed using the Healing Brush Tool, providing there is something in the photograph that can be used to cover over the glared section. The Healing Brush Tool is on the Tools toolbar on the left side of the screen (about four or five buttons down from the top). There are a number of tools on this toolbar button, so you may have to click on the button, keep the mouse button held down and wait for a short list to appear before selecting the Healing Brush Tool.

Hot Tip

Press J on the keyboard to switch on the Healing Brush Tool.

Above: Photoshop's Healing Brush Tool can be used to remove the glare on this car's bodywork, replacing it with parts of the car that are not affected by the bright sunlight.

Check the Healing Brush Tool's Settings

After selecting the Healing Brush Tool, check its settings along the Options bar, across the top left of the screen. For example, it may help to increase the size of the Healing Brush Tool (click on the drop-down triangle, second left on the Options bar), or change the Mode from Normal to Replace.

Remove the Glare

Position the mouse pointer over an area in the photograph that can be used to copy over the sunspot, glare or reflection. Hold down the Alt (or 'Option') key on the keyboard, then click with the mouse (left mouse button for a PC) to set the copy area. Next, move the mouse pointer over the sunspot or glare and click to start using the Healing Brush Tool. The sunspot, glare or reflection should begin to disappear. You may need to click repeatedly with the mouse, or hold the button down and swipe across the sunspot, glare or reflection.

Watch the Cross

When using the Healing Brush Tool, look out for a small cross, which indicates what is being copied. The cross moves in relation to the mouse when its button is held down. If the wrong area is being copied, click on the Edit menu to undo or step backwards, then repeat the previous procedure to select the area in the photograph to copy.

Left: The sunlight glare on the side of this car can be removed using the Healing Brush Tool, but it is important to know what the Healing Brush Tool is copying.

REMOVE A REFLECTION WITH A PATCH

An unwanted reflection can sometimes be removed using the Patch Tool. This tool is on the same toolbar button as the Healing Brush and Red Eye tools (the Tools toolbar down the left side of the screen). Click and hold the mouse button (left button for a PC mouse) on this toolbar button until a list appears – select Patch Tool from the list.

Draw a Patch

After selecting the Patch Tool, select Destination from the Options bar across the top of the screen. The next stage in removing a reflection using the Patch Tool is to draw a box around a part of the photograph that can be used to cover over the unwanted reflection. This box can be used several times to hide reflections, so it does not need to be the same size as the reflection that needs to be covered over.

Above: The unwanted reflection on the side of this car can be removed using Photoshop's Patch Tool.

Move the Patch over the Reflection

Once a box has been drawn around part of the photograph that can be used to cover over the unwanted reflection, drag and drop it on to the reflection. Continue dragging and dropping the box over other areas of the unwanted reflection to remove it.

Hot Tip

Press Ctrl and D (PC) or Command and D (Mac) on the keyboard to remove a Patch Tool box from the screen.

REMOVING UNWANTED SHADOWS

When the photographer's shadow cuts into a photograph or bright sunlight creates dark shadows underneath people's eyes, Photoshop can be used to remove or reduce these problems.

STAMP OUT OR HEAL A SHADOW

If the photographer's shadow cuts into photograph, then it can usually be removed using the Clone Stamp Tool or the Healing Brush Tool. Both of these tools are available on the Tools toolbar on the left side of the screen and are part of other toolbar buttons, so you may need to click on the relevant button, then hold the mouse button down (left button for a PC) until a list appears and the correct tool can be selected.

Clone Stamp Tool

After selecting the Clone Stamp Tool from the toolbar buttons on the left side of the screen, right click (Ctrl and click for the Mac) inside the photograph and change the settings for the size of the tool and the hardness, then

Above: The shadow in the bottom of this photograph can be removed using the Clone Stamp Tool, which copies another part of the ground over it.

Hot Tip

Press S on the keyboard to switch on the Clone Stamp Tool and press J to switch on the Healing Brush Tool.

press Return/Enter on the keyboard to remove the settings box. Next, position the mouse pointer over part of the photograph that can be used to copy over the shadow. Hold down the Alt (or 'Option') key and select this area by clicking with the mouse. Release the Alt/Option key, then move the mouse pointer over the shadow and start clicking to copy over it.

Healing Brush Tool

After selecting the Healing Brush Tool from the Tools toolbar on the left side of the screen, change the Mode setting on the Options bar (across the top left of the screen) from Normal to Replace. Right click (Ctrl and click for the Mac) inside the photograph and change the settings for the size of the tool and the hardness, then press Return/Enter on the keyboard to remove the settings box. Next, position the mouse pointer over a part of the photograph that can be used to copy over the shadow. Hold down the Alt (or 'Option') key and select this area by clicking with the mouse. Release the Alt/Option key, then move the mouse pointer over the shadow and start clicking to copy over it.

Above: Set the Mode for the Healing Brush Tool to Replace and check its size and hardness before removing a shadow.

REMOVING SHADOWS FROM EYES

Dark shadows under people's eyes can sometimes make them difficult to see, but these areas can be lightened using the Dodge Tool, which is covered earlier in this chapter under the section Dodging, Burning and Sponging (see pages 77–78).

Hot Tip

When copying over a shadow with the Clone Stamp Tool or Healing Brush Tool, hold the mouse button down and move the mouse over the shadow to quickly remove a large area of it.

ARTWORK

USING BRUSHES, PENCILS AND A HIGHLIGHTER

Photoshop's brushes and pencils can be used to add artistic designs to images, draw a footpath on a landscape photograph and add editing comments and marks to a work-in-progress image.

WHERE ARE THE BRUSH AND PENCIL TOOLS?

The Tools toolbar on the left side of the screen (usually about one third of the way from the top of this toolbar). Both tools share the same button with the Colour Replacement Tool and Mixer Brush Tool (depending on the version of Photoshop). To choose either the Brush or Pencil, position the mouse pointer over this toolbar button, hold the mouse button down (left button on the PC) and wait for a list to appear before selecting one of them.

Hot Tip

Switch between the Brush tools by pressing Shift and B on the keyboard.

Above: The Brush and Pencil tools can be found on the Tools toolbar on the left side of the screen.

CHOOSE A COLOUR

Choosing a colour for a Brush or Pencil is important and is separate to selecting these tools and changing their settings. The quickest way to select a colour is to click on the Foreground colour button near the bottom of the Tools toolbar. Make sure you click on the Foreground colour box, not the one behind it for the background. When a dialogue box appears, make sure it is for the

foreground. A colour can be chosen from the colour charts inside the dialogue box, or by clicking on a colour inside the image that is open in Photoshop.

Above: The colour of a Brush or Pencil has to be selected by choosing a foreground colour.

FILL IN THE GAPS

The Brush and Pencil tools can be useful for filling in gaps in an image using a variety of ready-to-use designs. After selecting the Brush or Pencil, right click (PC) or Ctrl and click (Mac) inside the image and a settings box will appear with a choice of Pencil or Brush styles and a value for the size and, in some cases, hardness. Once this has been set, press Return or Enter on the keyboard and the settings box will close. Click inside the image to brush or pencil in the chosen style.

Left: The Brush Tool can be used to fill in the sky with more tree foliage. The original image is displayed in the top left corner.

Above: Using the Pencil Tool allows a walking route to be drawn on a landscape photograph or map.

ADD A ROUTE TO A LANDSCAPE PHOTOGRAPH

Some walking and mountaineering books mark out routes and paths on landscape or aerial photographs to help illustrate the direction of a particular walk or climb. This is relatively straightforward to achieve using Photoshop. With the image on screen, select either the Brush or Pencil and make sure the colour and settings are suitable. Next, position the mouse pointer at the start of the route to be drawn, hold the mouse button down (left button for a PC) and move the mouse to carefully draw the route.

Hot Tip

The Color Replacement Tool is useful for highlighting specific areas in an image or photograph without concealing them.

ADD STARS AND GLITTER TO GREETINGS CARDS

Photoshop's Brush Tool is useful for adding artistic-looking stars, glitter and other artwork to your own greetings cards. After selecting the Brush Tool, right click or Ctrl and click to change the settings of the Brush and choose a star, leaf or other designs. These can be used to create a border for a greetings card or the main artwork. Greetings cards are covered as a step-by-step guide in chapter 4 (see pages 136–38).

USING A HIGHLIGHTER

Photoshop has the equivalent of a highlighter pen. It is called the Color Replacement Tool and is on the same toolbar button as the Pencil and Brush. After selecting it, a foreground colour, size and hardness need to be selected in the same way as selecting the settings for a Pencil or Brush.

ADDING TEXT TO IMAGES

Text can be added to photographs and artwork to create posters, greetings cards, business cards, leaflets and logos. The following section explains how text is added in Photoshop and how it can be altered, edited and moved.

TEXT TOOLBAR BUTTON

Text in Photoshop is created using the Type Tool, which is a button on the Tools toolbar (it looks like a letter T). There are a number of different Type tools for creating horizontal and vertical text and whether it is displayed as solid text or outline text containing the background of an image or photograph. To choose one of these, position the mouse pointer over the Type Tool button, hold the mouse button down (the left mouse button for a PC) and wait for a list to appear. Choose one of the Type tools from the list.

Above: Text is created using the Type Tool button, which has a number of different options.

Setting the Font, Size and Colour

The font, size and colour settings for text are all displayed along the Options bar across the top of the screen (underneath the menus). These are only displayed after selecting the Type Tool button. The following settings can be changed:

- **Font**: Click on the drop-down triangle to change the type of font used. A long list will drop down with samples of each.

- **Size**: Click on the drop-down triangle to choose a pre-set size for the font, or click inside the size value displayed and type in a different number.

Hot Tip

Press T on the keyboard to switch on the Type Tool.

Above: Text settings including font, size, colour and justification can all be changed via the Options bar and the Character and Paragraph palette.

→ **Regular/Italic/Bold**: Click on the drop-down triangle to select these options. These are not available for some of the fonts.

→ **Justification**: Select one of the justification buttons (left, centre or right) to determine the positioning of the text.

→ **Colour**: Click on the coloured button and a separate dialogue box will appear, allowing a colour for the text to be selected.

→ **Character and paragraph palettes**: Click on the button on the far right of the Options bar to open a palette with all of the above settings, plus additional justification and spacing options.

ADDING TEXT TO A PHOTOGRAPH OR IMAGE

Select the Horizontal Type Tool or Vertical Type Tool from the Type Tool button (left side of the screen). Select the settings for the text, then click inside the image to start typing the text. The text will probably not be in the correct position, but it can be moved later. If the text has to be typed on a second line, press Enter or Return on the keyboard. If, after typing the text, the size or look of it is wrong, select it and change the settings on the Options bar.

Hot Tip

Press Shift and T to switch between the different Type tools for creating text.

Move the Text

Photoshop will automatically create any text as a separate layer (look at the Layers panel near the bottom right of the screen). The text can be moved, by selecting the layer containing the text, clicking on the Move button at the top of the Tools toolbar (left side of the screen), then dragging and dropping the text.

Edit the Text

Select the Type Tool button that was used to create the text, then click inside the text. A flashing cursor should appear inside the text and it can now be edited. If this doesn't happen, select the layer containing the text (look at the Layers panel on the right side of the screen), then click inside the text.

Add More Text

Select the Background layer from the Layers panel on the right side of the screen, then select the Type Tool button on the left side of the screen. Click inside the image where the new text will be displayed and you are ready to start typing.

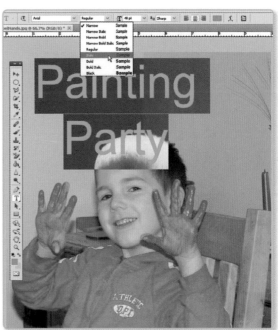

Hot Tip

Switch on the Move button by pressing V on the keyboard.

Above: If, after typing some text, it needs to be changed, select it and alter the settings on the Options bar.

Convert from Horizontal to Vertical

Horizontal text can be converted to vertical and vice versa. Right click (PC) or Ctrl and click (Mac) on the layer containing the text (in the Layers panel on the right side of the screen) and choose Vertical or Horizontal from the menu that appears.

Delete All the Text

Each piece of text is created as a new layer in Photoshop, so it is easy to delete individual ones. First, select the layer from the Layers panel on the right side of the screen, then press Delete on the keyboard, or right click or Ctrl and click on the layer and choose Delete Layer.

Flatten and Save

If you want to return to editing the text in an image, save it as a Photoshop PSD file (this type of file can store information about layers). When you have finished creating an image containing text, it is worth flattening it and saving it, so that it becomes compact and useable. Click on the Layer menu and choose Flatten Image.

Right: After creating an image containing text, there may be several layers that need to be flattened.

THE TYPE MASK TOOL

Photoshop's Type Mask Tool can be used to create outline shaped text that is placed over an image, allowing the image to show through the text. The steps involved in producing such artwork are quite complicated, so the following step-by-step guide shows exactly how to do it.

STEP BY STEP

1. Open or create an image, which can be used inside some text. This can range from a drawing to a photograph of people, objects or a landscape. Once the image has been created or opened, save it as a Photoshop PSD file by clicking on the File menu and choosing Save As.

2. Position the mouse pointer over the Type Tool button on the Tools toolbar (left side of the screen), hold the mouse button down (left button for a PC) and wait for a list to appear. Select either the Horizontal Type Mask Tool or the Vertical Type Mask Tool.

3. From the Options bar across the top of the screen, choose a thick, chunky font and a large size for it. This will ensure the letters are large enough for the image to be seen through them. The size and font can also be changed when typing the text.

4. The text has to be created in a new layer, so click on the Layer menu, choose New and select Layer from the sub-menu. From the dialogue box that appears, click on OK. Check the Layers panel on the right side of the screen (press F7 if you can't see it). A new empty layer should be displayed.

5. Make sure the new empty layer is selected in the Layers panel, then move the mouse pointer into the image and click once (make sure the Type Mask Tool is still selected). The image will turn red.

6. Type the text to be displayed in the image. If the text looks too small or too big, finish typing it, then select it and return to the Options bar along the top of the screen to change its size. The font can also be changed.

Above: The size of the text can be altered after it has been typed by selecting it and changing the settings on the Options bar.

7. When you have finished creating the text, click on the Move button at the top of the Tools toolbar. The mouse pointer will change to a black triangle and cross. Position the mouse pointer near to the text, but not inside it. Drag and drop the text to its correct location over the image. Remember, the image will only be visible through the text.

Above: After creating the text using the Type Mask Tool, it can be dragged and dropped using the Move Tool.

8. The text may need to be stretched to cover more of the image, so click on the Select menu and choose Transform Selection. A rectangle will appear around the text. Position the mouse pointer over the edges of the rectangle and, when it changes to a double-headed arrow, hold the (left) mouse button down and move it to alter the shape of the text.

9. The text can also be rotated by positioning the mouse pointer outside a corner of the rectangle. When it changes to a semicircular double-headed arrow, hold the (left) mouse button down and move it to rotate the text.

Above: The text can be rotated and stretched by clicking on the Select menu and choosing Transform Selection.

10. Press Enter or Return to remove the rectangle and switch off the Transform Selection editing. With the text complete, it is time to fill the rest of the image in with a solid colour. Click on the Select menu and choose Inverse – this will switch round the selection so everything but the text is selected.

11. The image, except for the text, can be filled using the Paint Bucket Tool. This is halfway down the Tools toolbar and shares its button with the Gradient Tool. After selecting it, click on the Foreground Color button near the bottom of the Tools toolbar and choose a fill colour. Finally, click inside the image (not in the text) and the selected colour will fill it.

Above: After inversing the selection, the Paint Bucket Tool can be used to fill everything but the text with a solid colour.

12. Press Ctrl and D (PC) or Command and D (Mac) on the keyboard to switch off selecting the text. The image is now complete and, if you wish to save it as a JPG, make sure it is flattened first (click on the Layer menu and select Flatten Image).

Hot Tip

Press Shift and G to switch between the Paint Bucket Tool and the Gradient Tool.

CONVERT A PHOTOGRAPH INTO A PAINTING

Photoshop has a number of effects that can turn a landscape photograph, portrait and many other types of photograph into a painting or make them look more artistic. The following pages reveal some of the popular methods.

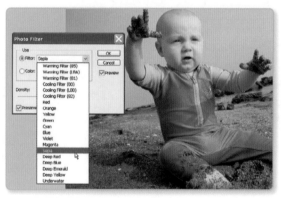

Above: Sepia toning can give an aged or artistic look to a photograph.

Hot Tip

Convert an image to black and white in later versions of Photoshop by holding down the Ctrl/Command, Alt and Shift keys on the keyboard (PC/Mac) and pressing B.

CONVERT TO SEPIA

Sepia toning is a traditional photographic production technique which helps to create an aged, tea-stained look to a photograph. There are two stages to converting an image to sepia in Photoshop, which are as follows:

➔ **Convert to black and white**: Click on the Image menu, select Adjustments and choose Black and White from the sub-menu. From the dialogue box that appears, Photoshop should automatically change the settings to ensure the image is now black and white (make sure the Preview option is ticked). Click on OK to close the dialogue box. In earlier versions of Photoshop, click on the Image menu, select Adjustments and choose Desaturate.

⊖ **Use a sepia filter**: Click back on the Image menu, select Adjustments and choose Photo Filter. From the dialogue box that appears, click on the drop-down list of filters and choose Sepia. Change the Density value to 100% and click on OK.

PAINT A LANDSCAPE

There are a wide range of filters available in Photoshop that can convert a landscape photograph into a painting. With a suitable photograph open in Photoshop, click on the Filter menu and choose Filter Gallery. A large window will appear with a number of filter categories listed near the top right. Click on one of them for a variety of choices to appear. The image will be displayed on the left, so select a filter type and the image will be changed (use the zoom controls in the bottom-left corner of the screen to change the size of the image).

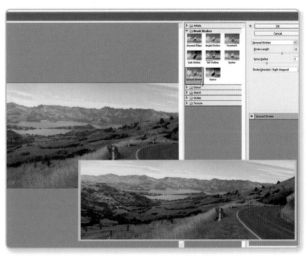

Above: A landscape photograph can be converted into a realistic-looking painting using one of the effects from the filter gallery. Here, the original image is displayed in the bottom-right corner of the picture.

Filter Limitations

A number of photographs will not successfully convert into a painting and, in some cases, no changes will be noticed when a particular filter is selected from the gallery. There are some settings on the right side of the Filter Gallery window that can help and are worth adjusting to see if the image can be changed. Also, try converting a photograph to black and white before using some of the filter effects. This can often produce better results.

Hot Tip

Try the Sprayed Strokes filter effect, which is under the Brush Strokes category of the Filter Gallery.

BOXES, LINES AND CIRCLES

Photoshop can be used to add boxes, lines, circles and other shapes to an image to help create diagrams, posters and leaflets. There are, however, some important rules to adhere to when creating such illustrations, which are explained in the following section.

SHAPES TOOLBAR BUTTON

The shapes that can be drawn in Photoshop are located on a button on the Tools toolbar on the left side of the screen. There are a number of ways of switching on this toolbar button, which are explained as follows:

Above: Different shapes can be selected from the button on the Tools toolbar on the left side of the screen.

➔ **Right/Ctrl and click**: Position the mouse pointer over the toolbar button for drawing shapes, then right click (PC) or Ctrl and click (Mac) and a list of shapes will appear. Choose one from the list.

➔ **Click and hold**: Position the mouse pointer over the toolbar button for drawing shapes, then hold the mouse button down (left button on a PC mouse) and wait for a list of shapes to appear. Select one from the list.

➔ **Press U**: This will switch on the draw shapes tool. The Options bar (see the next section) can then be used to select a particular shape, its colour and size.

➔ **Shift+U**: Hold down the Shift key on the keyboard and press U until the desired shape is displayed on the relevant Tools toolbar button.

Options Bar

Before proceeding with drawing a shape in an image, check the settings. These settings are displayed across the top of the screen along the Options bar (below the menus). From here, the style of the shape can be changed (for example, from a rectangle to a line), the colour can be altered and a fill pattern can be applied.

Draw the Shape

After selecting a particular shape and any settings for it, the method of drawing it is similar to most drawing packages: position the mouse pointer inside the image, hold the mouse button down (left button for a PC mouse) and move the mouse to draw the shape. Release the mouse button to stop drawing and create the shape.

Above: The colour and other details for a shape can be selected using the various settings along the Options bar.

LAYER, PATH AND FILL PIXELS

Each shape drawn in Photoshop can be created as a layer, a path or filled pixels. The choice can be selected near the top-left corner of the screen on the Options bar and is usually set to Layer. The consequences of each method are outlined in the following section.

Layer

When a shape is created as a layer, each shape is displayed as a separate layer in the Layers panel near the bottom-right corner of the screen (press F7 on the keyboard if it has disappeared). The Layers panel provides some settings for adjusting the fill and opacity criteria of the shape and, by selecting a particular shape's layer, the following can be done with it:

Hot Tip

If the Tools toolbar is missing, click on the Window menu and make sure there is a tick mark against Tools.

→ **Move the shape**: Select the Move button near the top of the Tools toolbar on the left side of the screen. The shape can now be dragged and dropped using the mouse.

→ **Delete the shape**: Press delete on the keyboard.

→ **Rotate, flip, skew**: Click on the Edit menu, choose Transform Path and select one of the options from the sub-menu. In some cases, press Enter or Return to exit from whatever transform feature is selected.

Above: A shape created as a layer can be rotated, skewed, moved and copied, just like any separate layer in an image.

Hot Tip

Press Ctrl (PC), or Command (Mac), and J, to create a copy of a layer.

→ **Resize**: Click on the Edit menu, choose Transform Path and select Scale from the sub-menu. Position the mouse pointer over the edges of the selected shape and, when it changes to a double-headed arrow, hold the (left) mouse button down and move the mouse to resize the shape. Press Enter/Return to switch this off.

→ **Copy**: Click on the Layer menu, choose New and select Layer via Copy from the sub-menu. Another layer will appear in the Layers panel, which contains the same shape.

Path

When a shape is created as a path, it is created as an object inside the image. The following can be done with this object:

Move the shape: Select the Path Selection Tool from the Tools toolbar on the left side of the screen (it looks like a black mouse arrow). Click on the shape and it will be selected by a series of dots along its edges and a box around it. Position the mouse pointer inside the shape, then drag and drop it to move it.

Above: When a shape is created with the Path button selected on the Options bar, it can be moved using the Path Selection Tool, as shown here.

Delete the shape: After drawing a shape, press Delete on the keyboard and it will be removed from the screen. Path shapes can also be deleted by selecting them with the Path Selection Tool (see previous instructions on moving a shape) and pressing Delete on the keyboard.

Rotate, flip, skew: Select the shape using the Path Selection Tool, then click on the Edit menu, choose Transform Path and select one of the options from the sub-menu. In some cases, press Enter or Return to exit whatever Transform feature is selected.

Resize: Select the shape using the Path Selection Tool, then position the mouse pointer over the small squares surrounding the shape. When the mouse pointer changes to a double-headed arrow, resize the shape by dragging the mouse (hold the [left] mouse button down and move the mouse).

Copy: Use the Copy and Paste commands on the Edit menu.

Hot Tip

Press A on the keyboard to switch on the Path Selection Tool.

Above: When a shape is created with the Fill Pixels button selected on the Options bar, it has to be selected using a tool such as the Magic Wand, Lasso or Marquee.

Fill Pixels

When a shape is drawn with the Fill Pixels button selected on the Options bar (near the top-left corner of the screen), the shape is created as part of the image, so it can be re-coloured, moved, deleted and resized in the same way as any other part of an image. The following methods explain how to do this:

➔ **Move the shape**: First, the shape has to be selected using one of the selection tools, such as the Magic Wand, Lasso, Quick Selection or Marquee. These tools were fully explained in chapter 1 (see pages 41–50). Once the shape has been selected, click on the Move toolbar button on the Tools toolbar (near the top-left corner of the screen), then drag and drop the selected shape. Unfortunately, after moving the shape, a space will be left, not the original image.

➔ **Delete the shape**: Use the Clone Stamp or Healing Brush Tool to remove the shape and replace it with the image's background.

➔ **Rotate, flip, skew**: Select the shape using one of the selection tools, such as the Magic Wand, Lasso, Quick Selection or Marquee. Click on the Edit menu, choose Transform and select one of the options from the sub-menu.

➔ **Resize**: Select the shape, as described above, then click on the Edit menu, choose

Transform and select Scale from the sub-menu. Position the mouse pointer over the edges of the selected shape and, when it changes to a double-headed arrow, hold the (left) mouse button down and move the mouse to resize the shape. Press Enter/ Return to switch this off.

Hot Tip

Press Ctrl and C on a PC keyboard or Command and C on a Mac keyboard to copy a selection.

→ **Copy**: Use the Copy and Paste commands on the Edit menu, although the pasted shape may be created as a layer.

Shape Confusion

Deciding which method of creating a shape (Layer, Path or Fill pixels) can be confusing and difficult to understand. What you want to do with the shape will determine how it is created.

Left: It can be difficult to determine the best method of creating a shape. Practise all options to find the best result.

CREATE A COMPANY LOGO

Photoshop can be used to create a variety of professional-looking images using its drawing tools and incorporating photographs and scanned artwork. The following step-by-step guide reveals some of the useful features in Photoshop.

Hot Tip

Create a new file in Photoshop by pressing Ctrl (PC) or Command (Mac), then N.

Left: Create a new image for the logo and make sure the settings are correct. When drawing any shapes for the logo, make sure the Layers button is selected on the Options bar.

STEP BY STEP

1 . The first step in creating a logo or similar artwork is to decide on the size of the image. Open a new image file in Photoshop by clicking on the File menu and choosing New. From the dialogue box that appears, make sure the size of the image, colour mode (for example, RGB for colour or Grayscale if black and white) and background colour are all correct, then click on OK.

2. There are several methods for creating a logo. Photoshop can create each part of the logo (shapes, artwork, images, text) as separate layers, which can then be moved around and overlaid. Use the Drawing tools outlined in the previous section of this

chapter to create boxes, circles and other shapes for the logo. When creating these shapes, make sure the Layer button is selected in the Options bar near the top-left corner of the screen.

3. Select the Background layer from the Layers panel, then add some text to the logo using the Type Tool – select this button from the Tools toolbar on the left side of the screen. Use the Horizontal or Vertical Type Tool and adjust the text settings (font and size) using the Options bar.

4. The text created in the previous step can be moved by selecting the Move button on the Tools toolbar, selecting the text layer from the Layers panel on the right side of the screen, then dragging and dropping the text. This can seem confusing at first.

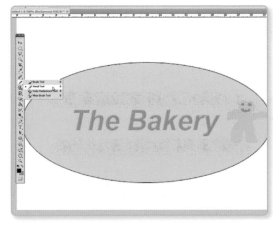

5. Use the Brush and the Pencil tools to create your own artwork. These can be found on the Tools toolbar. They can be combined with the Paint Bucket Tool (further down the Tools toolbar) to add fill colours.

Above: Artwork can be added to a logo using the Brush and Pencil tools.

6. As the logo is constructed, watch the Layers panel to see what happens when new artwork is added. This will help to determine how it can be moved, changed and deleted. When the logo is complete, flatten the image to make its file size smaller – click on the Layer menu and choose Flatten Image. The image may need to be cropped using the Crop button on the Tools toolbar. Finally, save the image.

Hot Tip

Made a mistake? Press Ctrl (PC) or Command (Mac), then Z, to undo it.

EDIT A PAINTING

If a painting has been photographed or scanned, then it can be opened in Photoshop and edited to add, change or remove detail. Photoshop can also apply a number of effects and filters to enhance the picture.

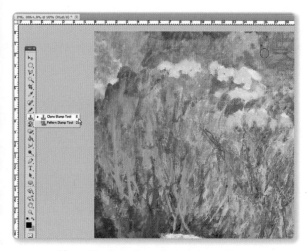

Above: The Clone Stamp Tool can be used to remove mistakes and unwanted parts of a painting by replacing them with other painted areas in the picture.

REMOVE OBJECTS AND COLOUR

The Clone Stamp Tool can be used to copy other objects and colour over particular areas of a painting or picture. This is useful where mistakes have been made and it is much easier and quicker than actually painting. First, select the Clone Stamp Tool from the Tools toolbar on the left side of the screen. It is about one third of the way down this toolbar and the button is shared with the Pattern Stamp Tool. Right click or Ctrl and click on the button, then select Clone Stamp Tool.

Select and Stamp

The Clone Stamp Tool works by selecting an area on an image, then using it to copy over another part of the image. Consequently, the first step is to position the mouse pointer over the area to copy, hold down the Alt (or 'Option') key on the keyboard and click with

Hot Tip

Press S on the keyboard to switch on the Clone Stamp Tool.

Hot Tip

Right click (PC) or Ctrl and click (Mac) inside the image when using the Smudge or Dodge tools to change the size and hardness of it.

the mouse button (left click for a PC mouse). The area for copying has now been selected. Next, position the mouse pointer over the area to copy over, hold the mouse button down and move the mouse to begin copying over.

Wrong Stamping

When using the Clone Stamp Tool and moving the mouse with its button held down, the area to copy from also moves – look for a cross that indicates the part of the image that is being copied. If the area that is being copied is wrong, then the correct area will need to be selected again.

SMUDGE THE PAINT

Photoshop can smudge the paint in a painting, just like an artist would smudge the paint with a finger or wet rag. Photoshop has a Smudge button, which is halfway down the Tools toolbar and shared with the Blur Tool and Sharpen Tool. The quickest way to select it is to locate the relevant toolbar button and, if it is the Blur Tool or Sharpen Tool, right click or Ctrl and click on the button and select Smudge Tool. Once selected, move the mouse pointer over the image and hold the mouse button down (left button for a PC mouse) to begin smudging.

Above: Parts of a painting can be smudged in the same manner as an artist would smudge paint using a finger or wet rag.

Adjust the Smudge Settings

If the smudging is too slight or too exaggerated or not very effective, the settings can be altered. Look along the Options bar across the top left of the screen. There are settings here for the size of the Smudge Tool, brush effects, hardness and strength of smudging. Try changing these settings to get some better results.

BRIGHTEN THE COLOURS

The colours in parts of a painting can be lifted and brightened up using the Dodge Tool. Whilst this is a traditional photographic printing technique, it is also effective with paintings. The Dodge Tool is on the Tools toolbar and shares the same button as the Burn Tool and Sponge Tool (these can also be used to darken and alter parts of a painting). Press O on the keyboard to switch on one of these tools and highlight the button. If the wrong tool has been selected (the Dodge Tool looks like a black lollipop), right click (PC) or Ctrl and click (Mac) on the button and choose Dodge Tool.

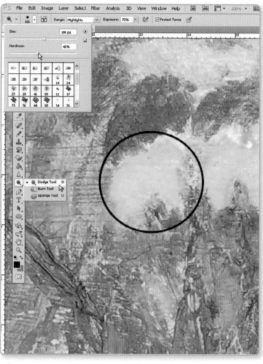

Above: The Dodge Tool can be used to brighten up parts of a painting.

Dodge Adjustments

The Dodge Tool may need its settings to be adjusted before it can be used. Its settings are displayed on the Options bar across the top left of the screen. The size and hardness settings are particularly important. Once adjusted, the Dodge Tool needs to be positioned over a part of the painting that requires brightening. Hold the mouse button down (left button for a PC mouse) and move the mouse to begin dodging, which should increase the brightness of that area.

Hot Tip

When using the Dodge Tool, right click (PC) or Ctrl and click (Mac) inside an image to change its size and hardness.

MAKE A PAINTING MORE ARTISTIC

Photoshop's range of filters can transform a painting into a different style, such as a watercolour or oil effect. Click on the Filter menu and choose Filter Gallery. From the window that opens, select a category of filter from the list near the top-right corner of the screen, then choose a particular style. Depending on the type of painting, some effects are better than others. For example, a watercolour filter on a scanned watercolour painting can produce an unexpected and successful effect.

Above: Photoshop's filters can change the effect of a painting.

Convert to Black and White

Sometimes, a painting can look better if converted to black and white. In early versions of Photoshop, save the image first, then click on the Image menu, choose Adjustments and select Desaturate from the sub-menu. In later versions, click on the Image menu, select Adjustments and choose Black & White from the sub-menu. A dialogue box will appear with colour settings, but, in most cases, click on OK to convert to black and white.

Hot Tip

Hold down the Alt, Shift and Ctrl/Command keys and press B to convert an image to black and white in later versions of Photoshop.

CREATE MULTICOLOURED TEXT

The colours of individual letters in some text can be quickly changed using the Paint Bucket Tool and a range of different fill colours. The following pages explain what is involved.

TYPE TOOL TEXT

Text created using the Horizontal Type Tool or Vertical Type Tool can be edited to feature different-coloured letters. The first stage is to create the text, so right click (PC) or Ctrl and click (Mac) on the Type Tool button (it has a letter T on it) in the lower half of the Tools toolbar on the left side of the screen.

Choose Horizontal Type Tool or Vertical Type Tool, then select a size and font from the Options bar along the top of the screen. Click inside the image and type the text. The text will be created as a separate layer and displayed in the Layers panel on the right side of the screen.

> ## Hot Tip
> **Press F7 if the Layers panel is not visible on the right side of the screen.**

Above: Text created with the Type Tool has to be converted to pixels by rasterizing it before individual letters can be re-coloured.

Rasterize or Flatten

After the text has been created, its individual letters cannot be coloured until the image has been rasterized or flattened. Flattening an image is the quicker method, so click on the Layer menu and choose Flatten Image. This will convert the text into pixels so they can be coloured. If you do not rasterize the text or flatten the image, a message box will appear when attempting to re-colour its letters.

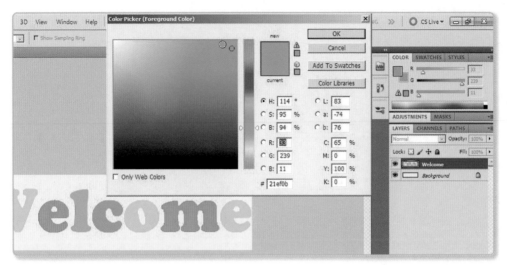

Above: Using the Paint Bucket Tool, different foreground colours can be added to individual letters in a piece of text.

Re-colour the Letters

Click on the Paint Bucket Tool button, halfway down the Tools toolbar. You may have to right click (PC) or Ctrl and click (Mac) on this button to select it because it shares the button with the Gradient Tool. Next, click on the Set Foreground Color button at the bottom of the Tools toolbar and choose a colour to use from the dialogue box that appears. Position the mouse pointer over one of the letters and click with the mouse (left button for a PC) to apply the foreground colour. Repeat this section to choose another colour and apply it to another letter.

Hot Tip

Press Shift and G on the keyboard to switch between the Gradient Tool and the Paint Bucket Tool.

Flatten and Save

Once the text has been suitably re-coloured, the image may need to be flattened if it contains layers (click on the Layer menu and choose Flatten Image). Finally, save the image file.

ADD A BORDER TO A PHOTOGRAPH

Photoshop can create a border for a photograph, so it can be printed and placed in a frame. The following step-by-step guide outlines what is involved.

STEP BY STEP

1. Open a photograph in Photoshop and make sure it is a suitable size for printing and displaying in a photo frame – click on the Image menu and choose Image Size. If necessary, alter the size of the image from the Image Size dialogue box. The image can also be cropped to a specific size using the Crop Tool on the Tools toolbar (enter settings for width and height in the Options bar to create a 6 x 4-inch print, for example).

Above: A border for a photograph can be created by firstly selecting an area using one of the Marquee tools (rectangular or elliptical).

2. Right click (PC) or Ctrl and click (Mac) on the Marquee button near the top of the Tools toolbar on the left side of the screen. Choose either a rectangular or elliptical marquee, depending on whether you want a round or squared-off border.

3. Draw a shape inside the image, which will form the inside edge of the border. The shape will mark the area of the photograph to be displayed. The area between the shape and the edge of the image will form the border.

Hot Tip

Switch on the Crop Tool by pressing C on the keyboard.

4. If the shape drawn in the last step needs to be changed, hold down the Shift key and select more areas to add to it, or hold down the Alt key and select areas to remove.

Above: After selecting the part of the photograph to appear inside the border, reverse the selection to colour in the border.

Above: A range of colours can be added to a border using the Gradient Tool, with more colours available on the Options bar.

5. Once the shape of the border has been drawn, click on the Select menu and choose Inverse. The selection now covers the border. Next, right click (PC) or Ctrl and click (Mac) on the Paint Bucket Tool button on the Tools toolbar and choose Gradient Tool. This will fill the border area with a range of colours, but first a colour has to be selected.

6. Click on the Foreground Color button at the bottom of the Tools toolbar. A dialogue box will appear with a choice of colours. Choose one and click on OK. You can also choose a gradient style (a way of creating a gradual blend in the colour) from the Options bar.

7. With the Gradient Tool still selected and a colour chosen, draw a line across or down one area of the border. This will determine whether the range of gradient colours runs down or across the border. After drawing the line, the colours will be applied. If you don't like the colours, return to step 6.

Hot Tip

Switch off a selection by pressing Ctrl (PC) or Command (Mac), then D.

CREATE GREETINGS CARDS AND INVITATIONS

Photoshop can be used to make personalized Christmas and birthday cards and invitations using your own photographs and the program's assortment of artistic tools.

STEP BY STEP

1. If you want to use a photograph as the main part of a card, then open it first and save it with a different name to preserve the original image. Otherwise, start with a blank image by clicking on the File menu and choosing New. From the dialogue box that appears, change the settings for the size of the image, its colour mode (click on Mode) and resolution (most printers print at a maximum of 300 pixels/inch).

Above: Text can be added to a greetings card and its size altered using the settings in the Options bar across the top of the screen.

2. If an existing photograph is being used to make a greetings card or invitation, the size of it may need to be changed, so click on the Image menu and choose Image Size. From the dialogue box that appears, check the settings for its size and resolution.

Hot Tip

Press F7 to show or hide the Layers panel on the right side of the screen.

3. Add some text to the card by clicking on the Type Tool button or pressing T on the keyboard. The Type Tool button is on the Tools toolbar on the left side of the screen (it looks like a letter T). Right click (PC) or Ctrl and click (Mac) on this button to choose between the Horizontal and Vertical type tools.

4. When typing the text on to the card, use the settings along the Options bar (across the top of the screen) to change the font, size and colour. After typing the text, it will also be displayed as a separate layer in the Layers panel on the right side of the screen. Select this layer from here, then click on the Move button at the top of the Tools toolbar to drag and drop the text inside the card.

5. Add some stars or other artwork to the card by selecting the Brush Tool from the Tools toolbar. The Brush Tool shares the same buttons as the Pencil Tool, Colour Replacement Tool and Mixer Brush Tool, so you may have to right click (PC) or Ctrl and click (Mac) on the button and choose the Brush Tool.

Above: The Brush Tool can be used to add a variety of coloured shapes to a greetings card or invitation.

Hot Tip

Press B on the keyboard to switch on the Brush Tool and Shift and B to switch to the Pencil Tool and other tools on the same button on the Tools toolbar.

Further Reading

Type Tool: Chapter 3, pages 109–15, 124, 130–31.
Brush Tool: Chapter 3, pages 106–08.

Above: Once the card has been created, compress any layers by flattening the image. This will make the file size smaller.

Hot Tip

Press Ctrl (PC) or Command (Mac), then P, to open the Print dialogue box.

6. After selecting the Brush Tool, select the Background layer from the Layers panels, then right click (PC) or Ctrl and click (Mac) inside the card to change the settings for the Brush Tool. After choosing a particular shape, press Enter/Return to remove the settings box. Next, choose a colour for the Brush Tool by clicking on the Foreground Color button near the bottom of the Tools toolbar – a dialogue box will appear with colour choices. Finally, you are ready to click inside the card and apply the Brush Tool.

7. When you have finished creating the greetings card or invitation, flatten the image to make its file size smaller – click on the Layer menu and choose Flatten Image. The image can now be saved as a compact file size, such as a JPEG. Finally, when you are ready to print the image, click on the File menu and choose Print, then check the print settings and make any adjustments.

REMOVE A SCRATCH FROM A SCANNED PHOTO

Scanned photographs, negatives and transparencies can sometimes include dust marks, dirt and scratches, especially if they are old. Fortunately, Photoshop can repair this damage and edit the image to look better than the original.

STEP BY STEP

1. With the image open in Photoshop, look for any dust marks and scratches. Zoom in and out of the image using the Zoom button at the bottom of the Tools toolbar. When you have located some damage that needs to be removed, select the Healing Brush Tool on the Tools toolbar. You may have to right click or Ctrl and click on this button to choose the Healing Brush Tool.

Hot Tip

Press Ctrl (PC) or Command (Mac), and + or −, to zoom in or out.

2. Change the settings for the Healing Brush Tool (especially the size and hardness) using the controls on the Options bar. Position the mouse pointer next to a dust mark or scratch, but not over it. Move the mouse pointer over part of the image that can be used to copy over the dust mark or scratch, hold down the Alt (or 'Option') key, then click once with the mouse and release the Alt/Option key. Next, move the mouse pointer over the scratch or dust mark, hold the mouse button down and see if the Healing Brush Tool copies over it.

3. In some cases, tools including the Spot Healing Brush and Patch Tool, which both share the same button as the Healing Brush Tool, can be useful for removing scratches and dust marks. If a tool doesn't work, click on the Edit menu to Undo and Step Backward to reverse any changes.

4. Once the image has been cleared of any marks, it may be beneficial to let Photoshop adjust any colour or black and white settings, plus the brightness and contrast of the image. Click on the Image menu, choose Adjustments and select Brightness/Contrast from the sub-menu. From the dialogue box that appears, see if any changes to the brightness and contrast settings make a difference.

5. Other image settings that can be altered include Levels, which is found by clicking on the Image menu, selecting Adjustments and choosing this option from the sub-menu. There are also some automatic corrections for tone, contrast and colour, which may help.

6. The Unsharp Mask can often help to make old black and white prints look crisper. This is found by clicking on the Filter menu, selecting Sharpen and choosing Unsharp Mask. From the dialogue box that appears, carefully adjust the settings to see if the image is improved.

Above: The Healing Brush Tool can be used to remove scratches and dust marks from an old scanned photograph.

Above: The Unsharp Mask can make a scanned black and white print look crisper, but do not over-adjust the settings and be prepared to see more scratches and dust marks.

MAKE A PASSPORT PHOTOGRAPH

Create your own passport photographs using Photoshop to help produce the correct white background and create the correct-sized prints.

STEP BY STEP

1. Open a suitable image in Photoshop that can be used to create a passport photo. This must be a photograph of a person who is looking straight at the camera, is not smiling and is not wearing anything that hides his/her features, such as glasses or a hat.

Hot Tip
Press C on the keyboard to switch on the Crop Tool.

2. If the passport photo has to be taken from a photograph containing other people or objects, then the person can be cut out of the image using the Crop Tool and cropped to the correct size. Click on the Crop Tool button near the top of the Tools toolbar on the left side of the screen. Enter the width and height for the passport photo (in the UK,

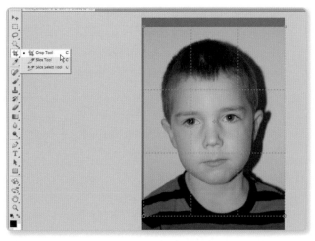

Above: A passport photo needs to be cropped to the correct dimensions. After choosing the Crop Tool shown here, enter the correct width and height for the photo, then draw a box over the image to crop it.

this is 3.5 x 4.5cm), then draw a box over the image to crop it. Make sure the box covers the person's head and shoulders, then double click inside it to crop it.

3. If any unwanted objects or shadows are in the photograph, remove them using the Clone Stamp Tool or the Healing Brush Tool. These tools can be found on the Tools toolbar on the left side of the screen. After choosing one of them, position the mouse pointer over an area of the photograph that will be used to copy over the unwanted object or shadow, hold the Alt (or 'Option') key down, then click with the mouse. Next, position the mouse pointer over the unwanted object or shadow and click with the mouse to copy over it.

4. The background on most passport photographs needs to be white, and Photoshop can help to lighten this to ensure it is the correct colour. First, try to select the background using the Magic Wand, which is near the top of the Tools toolbar. Click inside the background and see if Photoshop selects all of it. If any of the background is omitted, hold the Shift key down and click on the missing bits.

Above: Use the Clone Stamp Tool to remove the unwanted shadow in this photograph. Right click or Ctrl and click inside the image to change the size of the Clone Stamp.

5. After selecting the background, click on the Image menu, select Adjustments and choose Brightness/Contrast from the sub-menu. A small dialogue box will appear. Adjust the slider for Brightness

Hot Tip

Switch on the Magic Wand by pressing W on the keyboard.

until the background is the correct colour or shade.

6. If the background is not the correct colour after adjusting the brightness, select the Paint Bucket Tool from the Tools toolbar, halfway down the left side of the screen. After selecting it, click on the Foreground Color button at the bottom of the Tools toolbar and, from the dialogue box that appears, choose the correct background colour (white) and click on OK to close the dialogue box. Finally, click inside the background to change its colour.

Above: Adjust the brightness of the passport photo's background to ensure it is the correct shade and colour.

7. Several passport photographs can be printed on to photographic printing paper by creating a new image and adding multiple copies of the photograph. First, check the size and resolution of the passport photograph by clicking on the Image menu and choosing Image Size. From the dialogue box that appears, make sure the width and height are correct and, if necessary, adjust the resolution to a value such as 300 pixels/inch. Click on OK to close this dialogue box.

8. Click on the File menu and choose New to create a new image. From the dialogue box that appears, adjust the settings to the size of the photographic printing paper and make sure the resolution is the same as the passport photo. Click on OK and a new image will appear on screen.

Above: Create a new image to copy/paste multiple passport photos.

9. Return to the passport photo (click on the Window menu if you cannot see it and select the filename from the bottom of the list), click on the Select menu and choose All, then click on the Edit menu and choose Copy.

Hot Tip

Hold down the Ctrl (PC) or Command (Mac) key and press C to copy and V to paste.

10. Open the blank image created in step 8, click on the Edit menu and choose Paste. A copy of the passport photo will appear inside the image. Select the Move tool at the top of the Tools toolbar, then drag and drop the copied photo to a corner of the image. Click on the Edit menu again and choose Paste. A second photo will appear. Move it again and repeat this step until the space is filled with passport photos.

Above: Several passport photographs can be copied/pasted into a new image, then printed on to photographic paper.

11. Each copy/pasted passport photo can be moved by selecting it from the Layers panel on the right side of the screen (press F7 if it is not visible), then use the Move Tool as described in the previous step. When all the passport photos are correctly positioned, click on the Layer menu and choose Flatten Image to reduce the file size.

12. The passport photos can now be printed on to a suitable size of photographic paper – click on the File menu and choose Print, then change the settings to suit.

Hot Tip

Remember – you can press V to switch on the Move Tool.

COMBINE TWO PHOTOS TO MAKE A GOOD ONE

When a photograph of people takes several attempts to take and never results in a shot of everyone looking happy, Photoshop can be used to combine them to create a successful shot.

STEP BY STEP

1. Open two photographs that can be combined to produce a better result. Click on the Window menu, choose Arrange and select Tile to see them side by side. Use the Zoom toolbar button near the bottom of the Tools toolbar to adjust the size of each image on the screen.

Above: Use the Zoom button to zoom in and out of each image.

2. Decide which image is going to be the final one. Use the selection tools (Magic Wand, Quick Selection, Lasso, Marquee) to select part of another image, which will be copied into the final image.

Hot Tip

PC mouse: Hold down the Alt key on the keyboard and rotate the mouse's scroll wheel to zoom in and out of an image.

3. After selecting part of an image, its brightness and contrast may need to be altered, so click on the Image menu, select Adjustments and choose Brightness/Contrast from the sub-menu. A Brightness/Contrast dialogue box will appear. Alter the controls for brightness and contrast until the selected part of the image looks similar in lighting to the final image it will be copied into.

Above: After selecting part of the image on the left, its brightness can be reduced to ensure it does not look out of place when copied over to the image on the right.

4. With part of an image selected, click on the Edit menu and choose Copy. Select the final image, then click on the Edit menu and choose Paste. The copied part of the first image will be pasted into the final image. Notice this is also displayed as a separate layer in the Layers panel on the right side of the screen (press F7 if the Layers panel is not visible).

5. Select the Move Tool from the top of the Tools toolbar, make sure the copied layer is selected in the Layers panel, then move the copied part of the image into the correct position on the final image.

Above: After selecting part of the left-hand image, it can be copied and pasted into the right-hand image. The Move Tool is used to drag and drop this new layer into position.

6. The copied image's size may need to be slightly adjusted, so click on the Edit menu, choose Transform and select Scale from the sub-menu. A box will now appear around the copied image and it can be used to resize it. Position the mouse pointer over the edges of the box or the tiny squares around it. When the mouse pointer changes to a double-headed arrow, hold the (left) mouse button down and move the mouse to resize the image.

Further Reading

Layers: Chapter 1, Understanding Layers, page 62.
Selection tools: Chapter 1, pages 41–56.
Clone Stamp Tool: Chapter 2, Remove an Unwanted Date Stamp, page 94.

7. When you have finished adjusting the scale of the copied image, press Enter or Return on the keyboard to remove the box from around it (press Escape to reject the changes). The image may need to be moved again to make sure it is correctly positioned – use the Move Tool.

8. If the copied image is now in the correct position and is the correct size, it needs to be flattened with the final image before further editing can proceed. Click on the Layer menu and select Flatten Image.

9. The edges of the copied image may need to be tidied up in the final image. In our example, the copied image doesn't fully cover what it is supposed to replace. Click on the Clone Stamp Tool button, then right click (PC) or Ctrl and click (Mac) to set the size and hardness of it. Press Enter/Return to remove this box, then hold down the Alt or Option key on the keyboard and click on an area of the photograph that can be used to copy over any gaps. Next, click on the gaps to cover them over.

Hot Tip

Press S on the keyboard to switch on the Clone Stamp Tool.

CREATE A BUSINESS CARD

Photoshop's artwork tools can be used to create an illustrated business card containing stunning colours that are clearly presented and combined with a professional-looking photograph. The program can also print several copies of a business card on to one A4 sheet of thick paper.

STEP BY STEP

1. Open Photoshop and create a new file by clicking on the File menu and choosing New. From the dialogue box that appears, set the resolution to 300 pixels per inch (the maximum printing quality for most printers) and dimensions to the size of business card you want to create.

2. A photograph can be included in a business card and either positioned as a small image on part of the card, or made light enough to resemble a watermark. In both cases, make sure the image is open in Photoshop, then click on the Select menu and choose All to select the entire image. Click on the Edit menu and choose Copy, then switch to the new blank image created in step 1, click on the Edit menu and choose Paste.

3. After pasting a photograph into the business card, it may need to be resized. Notice the pasted image has been created as a separate layer and is displayed in the Layers panel on the right side of the screen (press F7 if it is not visible). Make sure this

Above: A photograph can be copied/pasted into a new image to create a business card. The pasted image is created as a new layer and displayed on the right side of the screen.

Hot Tip

Create a new file in Photoshop by holding down the Ctrl (PC) or Command (Mac) key on the keyboard and pressing N.

layer is selected, then click on the Edit menu, choose Transform and select Scale from the sub-menu. A rectangle with small squares will now surround the pasted image.

4. After selecting to scale the image, position the mouse pointer over the edges of the rectangle around it. When the mouse pointer changes to a double-headed arrow, hold the (left) mouse button down and move it to resize the image. Position the mouse pointer over a corner to resize the width and height together.

5. When you have finished resizing the image, press Enter/Return on the keyboard to complete the changes and the rectangle around the image will disappear. If the image has filled the business card, it may need to be made lighter, like a watermark. Click on the Image menu, choose Adjustments and select Hue and Saturation from the sub-menu. From the dialogue box that

Above: The image that has been pasted into the business card can be resized by clicking on the Edit menu, choosing Transform and selecting Scale.

Above: Adjust the Hue and Saturation's lightness to convert an image into a watermark so that text can be laid over it.

appears, increase the lightness and the image will become faint. Click on OK to complete the changes.

6. Add some text to the business card using the Type Tool button, which is halfway down the Tools toolbar on the left side of the screen. Right click (PC) or Ctrl and click (Mac) on this button (the button looks like a letter T) and choose either the Horizontal or Vertical Type Tool.

Above: Text can be displayed across and down an image using the Type Tool, with additional settings across the top of the screen for font, size and colour.

Choose a font, size and colour from the Options bar across the top of the screen before clicking inside the business card and typing some text.

7. If a piece of text needs to be moved, select its layer from the right side of the screen, then click on the Move Tool button at the top of the Tools toolbar (left side of the screen – it looks like a black triangle and a cross). Drag and drop the piece of text using the mouse.

8. Add a border to the business card using the Rectangle Tool near the bottom of the Tools toolbar. Select one of these tools (Rectangle, Rounded Rectangle, Ellipse), then draw it over the business card using the mouse. The shape will be created as a new layer.

9. The layers may need to be rearranged to ensure they are all visible. If one is not visible, select it from the right side of the screen, then click on the Layer menu, choose Arrange and select Bring to Front.

Hot Tip

Press Shift and T to switch between the different Type tools.

10. More images can be added to the business card by returning to step 2. When you have finished creating the business card, click on the Layer menu and choose Flatten Image to help reduce the file size. Save the image in a suitable file format, such as JPG.

Hot Tip

Press Ctrl (PC) or Command (Mac), then V, to paste.

11. The business card can be printed several times on an A4 sheet of thick paper. To do this, a new file will need to be created and the business card pasted several times into it. First, click on the Select menu and choose All – the entire business card will now be selected. Next, click on the Edit menu and choose Copy.

12. After copying the business card, click on the File menu and choose New. From the dialogue box that appears, enter the dimensions (for example, A4 paper width and height) and pixels per inch (for example, 300 for maximum resolution when printing). Click on OK and a new image will appear on screen.

13. Click on the Edit menu and choose Paste. Use the Move Tool to correctly position the pasted business card. Repeat this step to fill the page with business cards – each pasted business card is created as a separate layer.

14. When the new image is full of business cards, click on the Layer menu and select Flatten Image. Click on the File menu, choose Print and check the settings are correct before proceeding to print.

Above: A business card can be copied several times into a new A4-size image, then printed on to a thick sheet of A4 paper.

ADD TEXT TO A PHOTOGRAPH

Text can be quickly added to a photograph to make a for-sale poster, thank-you card or personalized postcard. The following step-by-step guide shows what is involved and how to create vertical and horizontal text.

STEP BY STEP

1. Open a photograph in Photoshop to which some text will be added. Make sure the image size is correct, so the text isn't too small or too large – click on the Image menu and select Image Size. From the dialogue box that appears, check the size and resolution, and change it if necessary.

2. Right click (PC) or Ctrl and click (Mac) on the Type Tool button in the lower half of the Tools toolbar (left side of the screen, it looks like a letter T). Choose the Horizontal or Vertical Type Tool, then change the font, size and colour settings using the controls in the Options bar across the top of the screen. Finally, click inside the image and type some text.

3. Text created with the Type Tool is displayed as a separate layer (look at the

Above: Text can be displayed vertically and horizontally using the Type Tool. The font, size and colour can all be adjusted.

Hot Tip

Most computer printers will print at a maximum quality of 300 dots/pixels per inch, so try to set an image's resolution to the same value.

right side of the screen for the Layers panel or press F7 if it is not visible). Each piece of text can be moved by selecting its respective layer, clicking on the Move Tool button at the top of the Tools toolbar, then dragging and dropping the text with the mouse.

4. Text that has been written can be edited by selecting the respective layer from the right side of the screen, clicking on the Type Tool button on the Tools toolbar, then clicking inside the text in the image. A flashing cursor will appear inside the text, allowing it to be edited and deleted.

5. An entire layer of text can be quickly removed by selecting its layer from the right side of the screen and pressing Delete on the keyboard. The layer will be instantly removed from the right side of the screen and its content removed from the image.

6. After adding the text to a photograph, once the image has been completed, flatten it to reduce its file size. Click on the Layer menu and choose Flatten Image. The image can now be saved as a file such as a JPEG.

Right: Each piece of text is created as a layer using the Type Tool, so, when the image is finished, flatten it to reduce its file size.

Hot Tip

Press Shift and T to switch between the different Type tools.

Above: The Horizontal and Vertical Type tools create text that is displayed in an image as a separate layer.

CREATE A SCHOOL PORTRAIT

A normal photograph of children in their school uniform can be quickly transformed into an official-looking school portrait using Photoshop. The following step-by-step guide shows exactly how to do it.

Right: Photoshop can be used to transform a normal photograph of children in school uniform into an official-looking school portrait.

STEP BY STEP

1. With a suitable image open in Photoshop, check and adjust its size so it can be printed – click on the Image menu and choose Image Size. From the dialogue box that appears, make sure the resolution matches your printer's quality setting (for example, 300 pixels or dots per inch) and the width and height of the image matches the size of the photographic paper to be used for the portrait. Whilst Photoshop will scale an image to suit a paper size when printed, it helps to avoid distortion if the image is correctly set first.

2. In most cases, the difference between an official school portrait and a photograph of children or a child in school uniform is the colour of the background or whatever is behind them. It is often difficult to photograph children at home with a plain background that will make the image look like a school portrait. Fortunately, Photoshop can cut out the background and change its colour.

Hot Tip

Zoom in and out of an image by holding down the Ctrl (PC) or Command (Mac) key and pressing the + or – keys.

3. Click on the Quick Selection Tool or, in earlier versions of Photoshop, the Magic Wand. Both tools share the same button on the Tools toolbar, so you may have to hold the (left) mouse button down over this button and wait for a list to appear before choosing the correct one. After selecting one of them, try to select the child or children in the photograph. Click and drag with the Quick Selection Tool, or hold down the Shift key and click over the image with the Magic Wand.

4. After selecting the child or children, there may be parts missing from the selection and unwanted parts selected. Hold down the Shift key and select missing parts. Hold down the Alt/Option key and unselect unwanted parts. Zoom in and out of the image to carefully select and unselect parts of the image.

5. If the Quick Selection Tool or Magic Wand cannot accurately select the child or children, switch to the Polygonal Lasso Tool near the top of the Tools toolbar. There are a number of Lasso tools, so position the mouse pointer over the respective button, hold the mouse button down (left mouse button for a PC) and

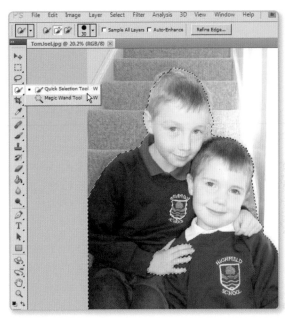

Above: Use the Quick Selection or Magic Wand tools to select the child or children in the photograph.

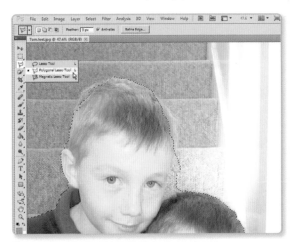

Above: The Polygonal Lasso Tool can be used to accurately select and deselect parts of the image.

wait for a list to appear before choosing Polygonal Lasso. Use the same controls outlined in step 4 to add to the selection and remove selected parts.

6. After accurately selecting the child or children in the photograph, save this selection, just in case you need to use it again in the future or it is accidentally unselected in the next steps. Click on the Select menu and choose Save Selection. From the small dialogue box that appears, enter a name for the selection (for example, kids) and click on OK. This selection will only be saved if the image is saved as a Photoshop PSD file.

7. There are several methods for changing the colour surrounding a subject such as a child. One approach is to copy the selected child or children as a new layer, then drop them into a new image containing a coloured background. To do this, make sure the child or children is/are still selected, then click on the Layer menu, choose New and select Layer via Copy from the sub-menu. A new layer will appear in the Layers panel on the right of the screen (press F7 if it is not visible).

8. A new file needs to be created to transfer the copied layer, but first the background colour for the new image has to be selected, so click on the Set Background Color button at the bottom of the Tools toolbar and choose a suitable colour. Next, click on the File menu

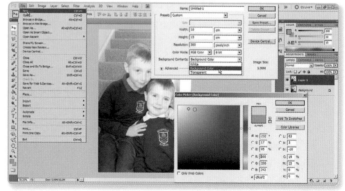

Above: Set a new background colour by clicking on the button at the bottom of the Tools toolbar, then create a new image file with this background colour that will form the new school portrait.

and choose New. From the dialogue box that appears, make sure the width, height and resolution are the same as the first image. Set the Background Contents to Background Color, then click on OK.

9. With the two images open in Photoshop, click on the Window menu, choose Arrange and select Tile (or a similar option to see both images side by side). Select the first image, then drag and drop the copied layer from step 7 into the new image with the coloured background.

Above: With the two images side by side, select the first image with the copied layer, then drag and drop the layer into the new image.

10. Click on the Move Tool button at the top of the Tools toolbar to drag and drop the pasted layer from the previous step and correctly position it. When the child or children is/are correctly positioned, click on the Layer menu and choose Flatten Image.

11. If any areas of the image need to be tidied, use the Clone Stamp Tool and Healing Brush Tool. These are covered in greater detail in chapter 1.

Further Reading

Selection tools (Lasso, Magic Wand): Chapter 1, pages 41–56.

CREATE A PANORAMIC PHOTOGRAPH

Photoshop's Photomerge can stitch a series of sequential photographs together to create one panoramic photo. The following step-by-step guide shows what is involved and how to resolve any problems that may arise.

STEP BY STEP

1. Make sure you have two or more photographs that have been taken in sequence to create a panoramic photograph. Open Photoshop, but don't open any images. Click on the File menu, select Automate and choose Photomerge. From the dialogue box that appears, click on the Browse button and locate the images you want to use to create a panoramic photograph.

2. After selecting the images to include in the panoramic photograph, choose a layout and any other options in the dialogue box (for example, Blend Images Together), then click on OK. Photoshop may take a few minutes to analyse the selected photographs and calculate how to blend them together to

Above: Locate the images to include in the panoramic photograph, select them and click on OK.

make a panoramic photograph. A progress box will appear on the screen to indicate that Photoshop is working. New layers will be added to the Layers panel on the right side of the screen.

Hot Tip

If the images are in the wrong order in a panoramic photograph, use the Move Tool (the 'V' key) to rearrange them.

3. When a stitched-together image appears on the screen, Photoshop has finished creating the panoramic photograph. The results may not be perfect, but they can be edited. For example, if one of the images is not correctly lined up, select it from the Layers panel on the right, then click on the Move Tool button at the top of the Tools toolbar and drag and drop that image into the correct position.

Above: Each image that makes up the panoramic photograph is represented by a separate layer on the right, so each one can be moved using the Move Tool, and its brightness and contrast adjusted.

4. If one of the images in the panoramic photograph is too light or too dark, select it from the Layers panel on the right, click on the Image menu, select Adjustments and choose Brightness/Contrast from the sub-menu. A dialogue box will appear, allowing changes to be made to adjust the image.

5. Save the panoramic photograph as a Photoshop PSD file, so you can return to editing it if necessary. Once all of the images are correctly lined up and the brightness across the entire photograph looks satisfactory, click on the Layer menu and select Flatten Image. All of the layers will be removed, leaving one.

6. Crop the image to tidy up the edges. Click on the Crop Tool button, then draw a box on the screen to mark out the new edges of the photograph. If the box is not the correct size, don't redraw it. Instead, position the mouse pointer over the edges of it and, when the mouse pointer changes to a

Above: Crop the image to tidy up any uneven edges.

double-headed arrow, hold the (left) mouse button down and move it to alter the crop box's size. Double click inside the box to complete cropping.

7. If there are any parts of the panoramic photograph where the joined edges of the photograph could be improved, try using the Smudge Tool to blend them together. The Smudge Tool is halfway down the Tools toolbar, along with the Blur and Sharpen Tools. Position the mouse pointer on this button, hold the mouse button down (left button for a PC mouse) and wait for a list of the tools to appear to choose the Smudge Tool.

8. The Clone Stamp Tool can also be used to fix any disjointed parts of the panoramic photograph. After selecting it from the Tools toolbar, hold down the Alt or Option key, then click on a part of the photograph that can be used to copy over the disjointed area. Release the keys on the keyboard and the mouse, then move to the area that needs to be fixed and click over it (left click with a PC mouse).

9. When you have finished creating the panoramic photograph, you can save it as a JPEG file, which is smaller than a Photoshop PSD file and can be viewed on a wider range of programs and computers.

Hot Tip

Press C on the keyboard to switch on the Crop Tool.

Taking Sequential Photos

The key to a successful panoramic photograph is the taking of sequential images with a camera. Some cameras have a setting for taking panoramic photographs, but if you don't have such a camera, the following points can help:

- Avoid zooming out fully with the camera. A wide angle creates distorted photographs, which are hard to join together.

- Do not alter the zoom settings whilst taking the sequential photographs.

- Take each sequential photograph with plenty of overlap and use points that are easy to recognize.

- Use a tripod for greater accuracy.

- Avoid creating panoramic photographs with moving subjects, which may appear more than once.

Hot Tip

Press S on the keyboard to switch on the Clone Stamp Tool.

Further Reading

Clone Stamp Tool: Chapter 2, Remove an Unwanted Date Stamp, page 94. Smudge Tool: Chapter 3, Smudge the Paint, page 127.

Right: Disjointed parts of a panoramic photograph can sometimes be fixed using the Smudge Tool.

PREPARE IMAGES FOR A WEBSITE

Images displayed on a website need to be the correct size to reduce download times and avoid delays. Photoshop can convert a large photograph from a camera into a small image with the correct dimensions that can be quickly displayed on a website.

STEP BY STEP

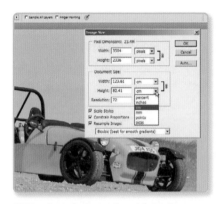

1. From within Photoshop, open the image that will be included in a website. Click on the Image menu and select Image Size. From the dialogue box that appears, look at the values for resolution, width and height. These values will probably be too large for a website.

2. Most websites display images at 96 dots (or pixels) per inch. Change this value in the Resolution part of the Image Size dialogue box. Next, change the width and height measurements to cm or inches, then change the values to the size the image needs to be when displayed on the website.

Above: Open the Image Size dialogue box to change the resolution and dimensions of an image to make it quicker to display on a website.

3. After changing the resolution and dimensions of the image, click on OK to apply the changes and return to the image. The size of the image may change on screen. Save the image, but, if you want to keep the original, click on the File menu and choose Save As – this will allow a new filename to be used and the original will be kept.

SAVE FOR WEB

Photoshop has a useful feature that can in many cases convert and save an image file for using with a website. Click on the File menu and choose Save for Web or Save for Web & Devices (the wording differs between different versions of Photoshop). If the image is too large, a warning box will appear, explaining that memory errors and slow performance may be experienced if you continue (you can choose to continue or exit by clicking on the Yes or No buttons). If successful, a window will appear with the image displayed and various settings.

Hot Tip

If Photoshop's Save for Web does not work, try reducing the image using our step-by-step guide.

Adjust the Save for Web Settings

With the Save for Web or Save for Web & Devices window open on screen, a sample view of the image will be displayed on the left (use the zoom controls to change its view). The following settings can be changed to ensure the image can be viewed on a website:

- **File type**: The image can be saved as a GIF, JPG and other file types, each with their own settings to reduce the file size. These settings are displayed near the top left of the window.

- **Display settings**: Choose Internet Standard RGB, Legacy Macintosh and other settings to see how the image will appear.

- **Image Size**: Just like the Image Size dialogue box, the image's size can also be altered here.

Above: If an image is too large and complex, Photoshop's Save for Web feature may not work.

MERGE PHOTOS WITH DIFFERENT EXPOSURES

Many cameras are now equipped with a High Dynamic Range function that takes several photos with different exposures and merges them together. Photoshop can do the same with its HDR feature.

STEP BY STEP

1. Open Photoshop, but do not open any images. Click on the File menu, choose Automate and select the HDR option on the sub-menu (the wording differs between different versions of Photoshop). From the dialogue box that appears, click on the Browse button and a second dialogue box will appear. Locate the image files that have been taken with the same content but with different exposure settings. Select these files and click on Open to return to the first dialogue box.

2. With the files listed in the dialogue box, click on OK to allow Photoshop to analyse the images and determine suitable exposure settings for all aspects of a final, combined image. This may take a few minutes to complete. Eventually, a window will appear with the merged photograph displayed.

Above: Photoshop's HDR function (High Dynamic Range) can combine a series of photographs that have the same content but different exposure settings.

Above: After Photoshop has combined all of the images, the resulting image will be displayed on screen. The settings to the right can change the image further.

Underneath, all the images that were selected in the previous step will be displayed with under/over exposure ratings next to each one (these are calculated by Photoshop).

Hot Tip

HDR can be used to merge photographs taken with and without fill-in flash.

3. The image can be further changed using the controls down the right side of the screen. Each alteration can be reversed if necessary. There are also some artistic settings, such as Surrealistic and Monochromatic. After making any alterations, click on OK to load the image into Photoshop. This may take a few seconds to complete and finally convert the HDR image.

4. The merged image is created as a new file and does not affect the images that were used to create it. If the new image needs to be used, it must now be saved.

Common HDR Errors

Photoshop's HDR function cannot successfully merge photographs that do not contain exactly the same composition. For instance, if a sequence of photographs is taken without a tripod, then the camera may move slightly and so the composition will probably change in each photograph. Consequently, Photoshop will not be able to merge such a group of photographs and the resulting merged image will look blurred. The only solution to this problem is to use a tripod. However, some cameras have an auto exposure bracket (AEB) function, which allows three or more photographs to be taken quickly in succession – this can often help to take successive photographs with the exact same content.

Right: If a series of photographs does not consist of the exact same composition, then a blurred merged image may be produced.

CREATE A COLLAGE

Several images of people, places and artwork can be cut out, scaled and added to one image to make a collage for greetings cards and posters. The following pages show what you can do in Photoshop.

CHOOSE THE BACKGROUND

The starting point in creating a collage is to choose a background image, on to which all other images will be pasted. The background can be another image, for example, but most of the content may become hidden as the image builds up with additional pictures. Alternatively, a new blank image can be used. In both cases, the size of the image needs to be determined to ensure it has the correct dimensions when printed.

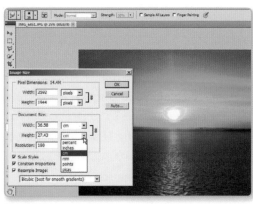

Above: If an existing image is being used as the background for a collage, check and change the size of it first.

Existing Image Size

If an existing image is being used as the background for a collage, then click on the Image menu and choose Image size. From the dialogue box that appears, make sure the dimensions (width and height) are correct (the measurement boxes may need to be changed from pixels to inches or cm) and the resolution matches the computer's printer quality – most printers can print up to a maximum of 300 dots/pixels per inch (usually called DPI).

Hot Tip

Press Ctrl (PC) or Command (Mac), and N, to create a new image.

New Image Size

If a new image file is being used as the background for a collage, click on the File menu and choose New to create it. A dialogue box will appear with a number of settings. Check and, if necessary, change the following:

⊖ **Dimensions**: Make sure the dimensions are measured in cm or inches, then change the width and height to suit the size of paper the completed collage will be printed onto.

⊖ **Resolution**: Change this value to the same quality setting as your computer's printer. Most printers can print at a maximum of 300 dots per inch (DPI, also known as pixels per inch or PPI).

⊖ **Background contents**: The new file will become filled with photographs and pictures, but, just in case there are any gaps, it may be worthwhile setting a particular colour to be applied, such as white. Click on the drop-down triangle for Background Contents and select White. If you want to use another colour, then the current background colour can be used (you may want to close the dialogue box, change the background colour, then repeat creating a new image file).

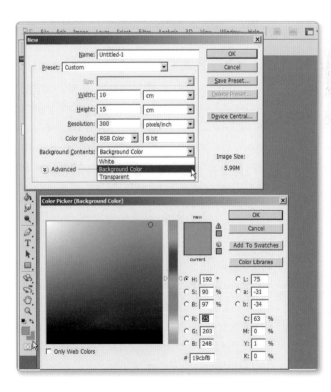

Right: A new file can be created as the background for a collage. A particular background colour can be applied by changing it first, then creating the new file.

Left: Text should be added using the Horizontal or Vertical Type Tool. Set the font, size and colour using the settings along the Options bar.

ADD TEXT

If the collage needs to include text for a greetings card, for instance, or as a title (for example, Holiday in France 2011), then this is often easier to add before any images are added to it. Right click (PC) or Ctrl and click (Mac) on the Type Tool button on the Tools toolbar (the button has a letter T on it) and a list of Type Tool options will appear. Select either the Horizontal or Vertical Type Tool. Set the font, size and colour using the controls in the Options bar across the top of the screen. Click inside the image to type the text.

Reposition Text

Text that is written using the Horizontal or Vertical Type Tool is created as a separate layer – look at the right side of the screen for the different layers in the image (press F7 if the layers are not visible). To reposition a piece of text, select its layer, then click on the Move Tool button at the top of the Tools toolbar. Use the mouse to drag and drop the text inside the image.

Hot Tip

Press Shift and T on the keyboard to switch between the different Type tools.

Amend and Delete Text

If some text needs to be changed, select the Horizontal or Vertical Type Tool button, select the layer containing the text, then click inside the text to edit it. Text can be deleted when editing it, but, if all the text needs to be deleted, the layer for the text should be deleted instead. To do this, select the respective layer from the right side of the screen, then press Delete on the keyboard.

PLACE IMAGES

Images can be added to the collage using the Place feature in Photoshop. Click on the File menu and choose Place. From the dialogue box that appears, locate and select an image to add to the collage, then click on the Place button. The image will be added to the collage, but will probably be too big. It will have a box and an x-shaped cross over it, allowing the image to be resized, moved and rotated as follows:

→ **Resize**: Position the mouse pointer over the edges of the box and, when it changes to a double-headed arrow, hold the mouse button down (left button for a PC mouse) and move the mouse to resize the placed image. This method can be difficult to proportionately resize the width and height together, so resize a corner of the image and hold the Shift key down on the keyboard to maintain the correct proportions.

Right: Complete images can be added to a collage by clicking on the File menu and choosing Place. Once an image has been added, it can be moved and resized, as shown here.

➔ **Move**: Position the mouse pointer inside the placed image, hold the mouse button down (left button for a PC mouse) and move the mouse to move the image.

Hot Tip

Images can be dragged and dropped into a collage, then resized, rotated and moved just like a placed image.

➔ **Rotate**: Position the mouse pointer next to a corner of the placed image, but not over the image. When the mouse pointer changes to a semicircular double-headed arrow, hold the mouse button down (left button) and move the mouse to rotate the image.

Switch off Placing

When you have finished resizing, rotating and moving the image, press Enter/Return on the keyboard and the box and cross will disappear. Notice the placed image is a separate layer and is displayed on the right side of the screen.

COPY AND PASTE IMAGES

Images can be added to the collage using the traditional copy and paste method. Click on the File menu and choose Open. From the dialogue box that appears, locate and select an image to include in the collage, then click on the Open button. The image will appear separately to the collage. If the entire image needs to be included in the collage, click on the Select menu and choose All, then click on the Edit menu and choose Copy. Return to the collage image

Hot Tip

Press Ctrl (PC), or Command (Mac), and A to select all of an image.

(click on the Window menu and select it from the bottom of the list), then click on the Edit menu and choose Paste.

Select Part of an Image

If part of an image needs to be included in a collage, use one of the following selection tools, then complete the instructions for copying and pasting:

Above: The whole of an image can be copied into a collage by clicking on the Select menu and choosing All.

→ **Marquee Tool**: Right click (PC) or Ctrl and click (Mac) on the Marquee Tool button at the top of the Tools toolbar and choose a Rectangular or Elliptical Marquee Tool to create one of these shapes inside the image. Draw a box over the image to create the selection.

→ **Lasso Tool**: Right or Ctrl and click on the Lasso Tool button at the top of the Tools toolbar and select a Polygonal Lasso to make a straight-edged selection, or Lasso Tool to make a freehand selection.

Cut Out an Object in an Image

People, animals and objects can be cut out of an image, then copied and pasted into the collage. This takes practice to perfect and is covered in greater detail in chapter 1 (*see* text on selection tools, pages 41–56) and chapter 6 (*see* Cut Out an Object on page 218). The

tools that can be used to select an object include the following:

- **Magnetic Lasso**: This is one of the Lasso tools and can select an object if its colour is different from its background. Click around the edges of the object to help select it.

- **Quick Selection Tool**: Available in later versions of Photoshop, this tool shares the same button on the Tools toolbar as the Magic Wand (near the top of the toolbar). Hold the mouse button down (left button for a PC mouse) and move over the object to let the Quick Selection Tool intuitively select it.

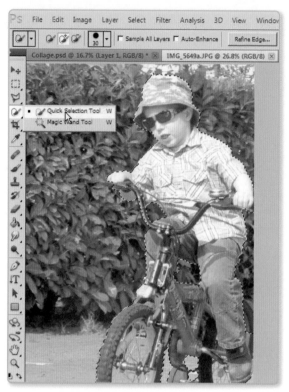

Above: The Quick Selection Tool in later versions of Photoshop is useful for quickly selecting an object in an image before copying and pasting it into a collage.

- **Magic Wand**: The Magic Wand selects an object based on its colour. Click inside part of the object and the colour the mouse pointer is positioned over will be selected, along with the same colour nearby. Hold down the Shift key and continue clicking to add more to the selection.

- **Pen Tool**: This is regarded as the most accurate method of selecting an object. It involves drawing a path around an object, then converting it into a selection. This is covered in greater detail in chapter 1, pages 54–56.

Hot Tip

Use a combination of selection tools rather than just one to accurately select an object in an image.

ARRANGE THE OBJECTS IN A COLLAGE

If an object in the collage is covering over another object, it can be brought to the front. First, select its layer from the Layers panel on the right side of the screen, then click on the Layer menu, select Arrange and choose one of the options from the sub-menu, such as Bring to Front.

Above: Objects can be moved in front or behind other objects when creating the collage. Here, the jackdaw is positioned behind the text.

RESIZE AND ROTATE OBJECTS IN A COLLAGE

Select the layer for the object that needs to be resized or rotated. All layers are displayed down the right side of the screen (press F7 if they cannot be seen). Click on the Edit menu, choose Transform and select one of the following from the sub-menu:

⊖ **Scale**: A box will appear around the object. Position the mouse pointer over the edges of the box and, when it changes to a double-headed arrow, hold the mouse button down (left button for a PC mouse) and move the mouse to resize the object.

⊖ **Rotate**: Either choose one of the rotate options (180° or 90° clockwise or counterclockwise), or select Rotate and manually rotate the object by positioning the mouse pointer around the outside of the image. When the mouse pointer changes to a semicircular double-headed arrow, hold the mouse button down (left button for a PC mouse) and move the mouse to rotate the object.

Left: Use the Transform feature on the Edit menu to resize and rotate objects that are pasted into a collage.

SAVE, FLATTEN AND FINISH

As the collage progresses, save it and regularly re-save it. The collage can be saved as a Photoshop PSD file when it is being created. This ensures information on the layers is retained. When you have finished adding images to the collage and they are all correctly positioned, flatten the image to reduce its file size – click on the Layer menu and choose Flatten Image. The collage can be further reduced in size by saving it as a JPEG file. Click on the File menu, choose Save As and, from the dialogue box that appears, change the file type to JPEG.

Hot Tip

Press Ctrl (PC), or Command (Mac), and S to save the collage regularly during its creation.

Above: When the collage is complete, reduce its file size by flattening it. The image shown here was 114MB before flattening. After flattening, it was reduced to less than 2MB as a JPEG.

REMOVING UNWANTED OBJECTS

If a lamppost appears to be growing out of the back of someone's head in a photograph, or electricity cables are stretching across an idyllic landscape scene, then Photoshop can remove these unwanted objects.

CONTENT AWARE IN CS5

Photoshop CS5 (and later versions) has a new feature that can help to remove unwanted objects in a photograph. It works by selecting a large area around the unwanted object that Photoshop then uses to fill over. The Polygonal Lasso Tool is probably the best tool for selecting this type of area. This selection tool is near the top of the Tools toolbar on the left side of the screen. Right click (PC) or Ctrl and click (Mac) on the Lasso Tool button, then choose Polygonal Lasso from the list that appears. Click around the unwanted object to draw a selection with the Polygonal Lasso.

Fill, Content Aware

After selecting an unwanted object, including whatever is around it, click on the Edit menu and choose Fill. From the dialogue box that appears, make sure Content Aware is selected from the drop-down list and the opacity setting is 100%. Click on OK to see if Photoshop can successfully remove the unwanted object. If it is not successful, click on the Edit menu and choose Undo.

Above: Photoshop CS5 has a new tool for removing unwanted objects. First, use the Polygonal Lasso Tool to select a large area around the unwanted object, then click on the Edit menu and choose Fill.

Hot Tip

Press Shift and F5 to open the Fill dialogue box.

STAMP OUT UNWANTED OBJECTS

An unwanted object can be removed using the Clone Stamp Tool, providing there is something in the image that can copy over it. The Clone Stamp Tool button is on the Tools toolbar on the left side of the screen (about one third of the way down). It shares its button with the Pattern Stamp Tool, so right click (PC) or Ctrl and click (Mac) on this button and choose Clone Stamp Tool from the list that appears. Alternatively, press Shift and S until the Clone Stamp Tool is displayed on its button on the Tools toolbar.

Adjust and Apply the Clone Stamp Tool

After selecting the Clone Stamp Tool, check its settings along the Options bar across the top of the screen. Make sure the Opacity is set to 100% and the size, shape and hardness are adequate. Move the mouse pointer to position it over a part that can be used to copy over the unwanted object. Hold down the Alt or Option key on the keyboard, then click once with the mouse (left button on a PC mouse). Next, position the mouse pointer over the unwanted object and click to copy over it. Whilst clicking, look for a small cross – this indicates what is being copied.

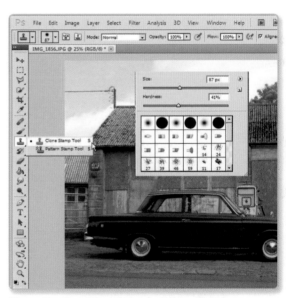

Above: The Clone Stamp Tool can remove unwanted objects by copying other parts of the image over them.

Hot Tip

Right click (PC) or Ctrl and click (Mac) inside the image to set the Clone Stamp Tool's size, shape and hardness.

SPECIAL EFFECTS

CREATE AN ACTION SHOT FROM A STILL

Photoshop has a selection of useful motion blur tools that can help transform a still image into a stunning action shot. The following pages outline what was involved in editing two images of cars that appeared on the front covers of motoring magazines.

Right: This front-cover photograph started as a still, but was edited in Photoshop to make the car look as though it is moving.

SELECT THE OBJECTS TO BLUR

The first stage in creating an action shot is to select the objects that need to look blurred to give the impression of action. In our example shown here, the road, wall, trees and sky need to be blurred to look as though the car is moving. However, it is easier to select the car, then inverse the selection to select the road, wall, trees and sky. The following selection tools on the Tools toolbar can be used to select the car in the photograph:

- **Polygonal Lasso**: Right click (PC) or Ctrl and click (Mac) on the Lasso Tools button, then select Polygonal Lasso. Click around the car to select it. Between each click point, the Polygonal Lasso Tool will draw a straight line, which is useful for selecting a straight-edged shape such as a car.

- **Pen Tool**: Right click (PC) or Ctrl and click (Mac) on the Pen Tool button and choose Pen Tool from the list that appears. Click around the car to draw a path around it. Each

click point can be moved after a complete path has been drawn. Once the path is complete and sufficiently accurate, it must be converted into a selection. This subject is covered in greater detail in chapter 1, pages 54–56.

Hot Tip

Press shift and L to switch between the different Lasso tools.

Save the Selection

After selecting an object, save it in case it is accidentally deselected. Click on the Select menu and choose Save Selection. From the dialogue box that appears, enter a name for the selection and click on OK.

Inverse the Selection

To select the road, wall, trees and sky, which will be blurred, you need to inverse the selection of the car. With the car selected, click on the Select menu and choose Inverse. Everything but the car will now be selected.

Left: The Polygonal Lasso Tool can be used to select an object.

BLUR THE BACKGROUND

With the road, wall, trees and sky selected, click on the Filter menu, choose Blur and select Motion Blur from the sub-menu. A small Motion Blur dialogue box will appear. Adjust the angle of the blur to the same angle as the photograph. Adjust the Distance value in pixels and make sure the Preview box is ticked to view the results. Do not adjust the Distance value too much as the image won't look realistic. When you've found the correct level of motion blur, click on OK to close the dialogue box.

Hot Tip

Press Ctrl and D (PC) or Command and D (Mac) to deselect part of an image.

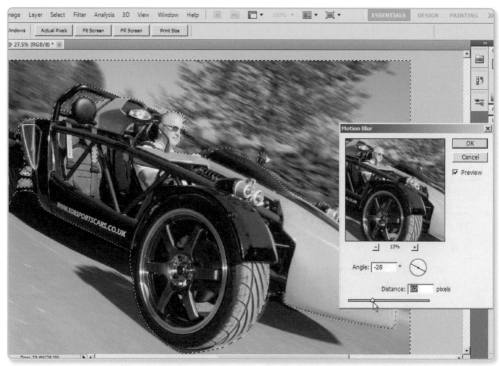

Above: Photoshop's Motion Blur can give the impression of an object moving by blurring its background.

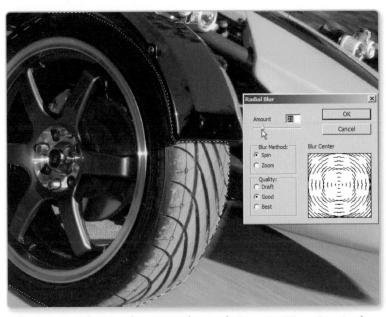

Above: A wheel of a car can be spun round to give the impression it is moving using the Radial Blur feature in Photoshop.

Spin the Wheels

Switch off the selection of the road, wall, trees and sky by clicking on the Select menu and choosing Deselect. Use the Polygonal Lasso Tool to select one of the wheels and tyres, then click on the Filter menu, select Blur and choose Radial Blur. From the dialogue box that appears, adjust the Amount value to around 20 and make sure the Spin option is selected, then click on OK (there is no preview option). If the amount of blur is too much, click on the Edit menu and choose Undo, then return to the Radial Blur dialogue box. Similarly, if the blur is too little, return to the dialogue box.

TIDY THE EDGES

Photoshop's Motion Blur can create some fuzzy edges and there may also be some areas that were not correctly selected, so they are not blurred. Fortunately, the Healing Brush Tool can fix these problems, but requires some patience to correctly adjust its settings on the Options bar.

Hot Tip
Press J on the keyboard to switch on the Healing Brush Tool.

Using the Healing Brush Tool

Right click (PC) or Ctrl and click (Mac) on the Healing Brush button on the Tools toolbar and select Healing Brush Tool from the list that appears. After adjusting its settings, move to an area that needs to be edited, position the mouse pointer over part of the image that can be used to copy over the affected area, hold down the Alt or Option key and click with the mouse (left click with a PC mouse) to select it. Move the mouse pointer to the area that needs to be edited and carefully click over it to copy the selected part of the image. This can take a long time to successfully complete.

Hot Tip

PC: Hold down the Alt key and rotate the scroll wheel to zoom in and out of an image.

Zoom In and Out

Zoom into the image to find the areas that need to be edited with the Healing Brush Tool. This will help you to inspect them closely and so fix them carefully.

Left: Rough edges may appear after applying Motion Blur and Radial Blur, but can be tidied up using the Healing Brush Tool.

SAVE THE FINAL IMAGE

It is important to save the image in two formats. First, it can be saved as a Photoshop PSD file, which enables any saved selections to be recorded and reused. However, this type of file is large and cannot be used in a wide range of programs. Instead, save it again as a JPEG file, which is smaller and easier to use in different programs (for example, on a website).

HEAD-ON ACTION

The Motion Blur tool is useful for creating the impression of movement passing by the camera. However, a more dramatic shot is one where the object looks as though it is travelling towards the camera. In this case, select the background and use the Radial Blur feature, but select the Zoom option. This will produce an effective motion blur, which, given the correct type of photograph, will look as though an object is about to jump off the page.

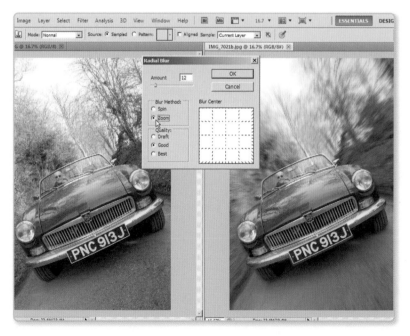

Left: Applying Radial Blur with the Zoom option selected can transform the background for this car and make it look as though it is moving towards the camera.

QUICK STEPS FOR DIRECT ACTION IMAGES

The following step-by-step guide provides another approach to converting a still photograph into the type of action shot where the subject looks as though it is travelling towards the camera or about to jump off the page.

Hot Tip
Press Ctrl and J (PC) or Command and J (Mac) to create a new, copied layer.

STEP BY STEP

1. Open a photograph in Photoshop which features a person, animal or object that is facing the camera and could be made to look as though it is travelling towards the camera. Copy the entire image into a new layer by clicking on the Layer menu, selecting New and choosing Layer via Copy from the sub-menu. Look at the Layers panel on the right side of the screen (press F7 if it is not visible). The copied layer should be displayed as Layer 1.

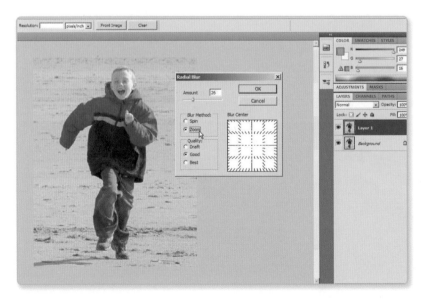

Left: After creating a copy layer, apply a zoom blur to add a sense of action.

2. With Layer 1 (the copied layer) selected from the Layers panel on the right side of the screen, click on the Filter menu, select Blur and choose Radial Blur. From the dialogue box that appears, select the Zoom option and adjust the Amount value to around 25. Click on OK. The image will now be blurred.

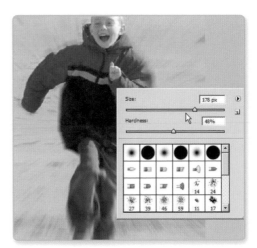

Above: Use the Eraser Tool to remove the blurred layer and reveal the background layer with the still image.

3. Select the Eraser tool from the Tools toolbar on the left side of the screen. You may need to right click (PC) or Ctrl and click (Mac) on this toolbar button and choose Eraser Tool. Right click or Ctrl and click inside the image to set the size and hardness of the Eraser Tool, then click over the areas of the subject in the photo that you do not want to be blurred. The subject will become clear again because the blurred layer is removed.

4. When you have finished removing parts of the blurred image to make the subject clearer, flatten the image by clicking on the Layer menu and choosing Flatten Image.

Correcting Eraser Mistakes

If you accidentally erase too much using the Eraser Tool, you may be able to reverse the mistake by clicking on the Edit menu and choosing Undo, then returning to the Edit menu and selecting Step Backward (this last command can be selected several times). Alternatively, blend in any mistakes using the Clone Stamp Tool.

Hot Tip

After blurring the copied layer, try adjusting its opacity in the Layers panel to help blend it into the background layer.

SHRINK AND ENLARGE OBJECTS

Objects can be increased and decreased in size to make children into giants and lizards into dinosaurs using Photoshop's Transform tools. The following pages show how you can create some amazing special effects.

SELECT AND GROW OR SHRINK

An existing object in an image can be selected and expanded or shrunk. Use one of the Selection tools (for example, Magic Wand, Lasso) to mark around an object such as a building, person or animal. After selecting the object, click on the Edit menu, choose Transform and select Scale. A box will appear around the selection. Position the mouse pointer over the edges of the box and, when it changes to a double-headed arrow, hold the mouse button down (left button for a PC) and move the mouse to change the size of the selection. The selection can also be moved elsewhere inside the image by dragging and dropping it.

Hot Tip

Press C on the keyboard to switch on the Crop Tool.

Tidy Up the Leftovers

Sometimes, an empty space will be left if a selection is shrunk or moved. This can be filled in two ways:

➔ **Clone Stamp Tool**: Copy another part of the image into the space using the Clone Stamp Tool.

Left: An object in an image can be selected using one of the selection tools, then shrunk. The space left can be filled or the image cropped.

➔ **Crop the image**: Reduce the area of the image using the Crop Tool and exclude the space.

ADD A SMALL OR LARGE OBJECT

Objects from other images can be added to another image, which is sometimes easier than trying to shrink or enlarge objects inside an image. Select an object using the selection tools, then click on the Edit menu and choose Copy.
Open the image to add the object to, click on the Edit menu and choose Paste. The pasted object will be created as a new layer inside the image.

Above: More objects can be pasted into an image and resized to make them look large or small.

Resize and Move the Pasted Object

Select the layer for the pasted object from the Layers panel on the right side of the screen. Click on the Edit menu, choose Transform and select Scale from the sub-menu. Resize and move the object in the same way as described for resizing a selection opposite. After resizing and moving it, press Enter or Return on the keyboard to complete the changes (press Escape to reject the changes).

Flatten the Image

When the image is complete, click on the Layer menu and choose Flatten Image. This will help to reduce its file size.

> ## Hot Tip
> Press F7 to hide or reveal the Layers panel on the right side of the screen.

CREATE A SUNSET

A normal scenic landscape photograph with dull grey clouds can be transformed by dropping a sunset into the sky using Photoshop. The following pages show how to do it.

COMPARE IMAGES

Using Photoshop, open the photograph with the dull sky and a photograph with a brighter sky, such as a sunset. Click on the Window menu, choose Arrange and select Tile (or a similar method of arrangement). Make sure there is enough sky in the second photograph to cover the sky in the first photograph (the first photograph is the one with the dull sky).

Select Everything but the Sky

Using one or a combination of Photoshop's selection tools (for example, Magic Wand, Quick Selection or Lasso), select everything in the first image, except the dull sky. It may be easier to select the sky, then click on the Select menu and choose Inverse to reverse the selection.

Once the selection has been made, it needs to be copied as a layer, so click on the Layer menu, select New and choose Layer via Copy from the sub-menu. Notice the copied layer appears on the right side of the screen in the Layers panel (press F7 if it is not visible).

Left: When selecting everything but the dull sky, it may be easier to select the sky, then inverse the selection.

Drag the Copied Layer into the Sunset

Make sure the two images are displayed side by side. Select the first image, with the dull sky, then position the mouse pointer over the copied layer on the right side of the screen (it is usually called Layer 1). Drag and drop this layer into the second photograph, containing the sunset or brighter sky. The copied layer will now appear inside the second photograph, but without its dull sky. However, it will probably be too large or too small, so it will need to be resized.

Resize the Copied Layer

Make sure the copied layer in the second photograph (the one with the sunset) is selected in the Layers panel on the right side of the screen. Click on the Edit menu, choose Transform and select Scale from the sub-menu. A box will appear around the copied layer and it may be easier to maximize the second photograph on the screen. Position the mouse pointer over a corner of the box and, when it changes to a double-headed arrow, hold the Shift key down on the keyboard and the button on the mouse (left button for a PC). Move the mouse to proportionately resize the width and height of the image.

Hot Tip

Selection tools, including the Magic Wand, Lasso and Quick Selection tools, are covered in greater detail in chapter 1.

Above: Hold down the Shift key on the keyboard when resizing the copied layer and the width and height will change in proportion to each other.

Hot Tip

When you've finished resizing a layer using the Transform–Scale option, press Enter/Return to accept the changes, or Escape to cancel them.

Alter the Angle

One of the problems of combining two photographs concerns the angles at which they were taken and whether they match when put together. Photoshop can help to resolve such issues using its Transform functions. With the copied layer still selected, click on the Edit menu, choose Transform and select Perspective, Skew or Distort. These tools display a box around the copied layer, allowing the edges of it to be dragged (similar to resizing) to alter the angle of the image. The best approach to using these tools is to try them and, if they don't work, press Escape on the keyboard (press Enter/Return to accept any alterations).

Brighten the Copied Layer

The brightness and contrast of the copied layer may look too dark or too light when compared with the second photograph's brighter sky. If this is the case, make sure the copied layer is selected from the layers panel on the right, then click on the Image menu, select Adjustments and choose Brightness/Contrast. From the dialogue box that appears, adjust the brightness and contrast settings and see if the copied layer looks better (make sure the preview box is ticked).

Flatten the Image and Crop

When the copied layer appears to be correctly positioned over its new sky, the layer can be merged with the photograph by clicking on the Layer menu and selecting Flatten Image. This reduces the file size of the photograph. The photograph may need to be cropped – use the Crop Tool on the Tools toolbar.

Above: The copied layer may look too bright or too dark, but it can be adjusted without changing the sky in the second photograph.

Blend the Edges

Closely inspect the edges of the copied layer to make sure they blend in with the second photograph. If they don't, use the Smudge Tool to blend them. This tool is halfway down the Tools toolbar on the left side of the screen and shares its button with the Blur Tool and Sharpen Tool. Right click (PC) or Ctrl and click (Mac) on this button to select the Smudge Tool from a list of these tools. Position the mouse pointer over the area that needs to be blended in, hold the mouse button down (left button on a PC mouse) and move the mouse to smudge the sharp edges.

Left: Right click (PC) or Ctrl and click (Mac) inside the image when using the Smudge Tool to adjust its settings, then smooth over any sharp edges created by the copied layer.

Hot Tip

The Smudge Tool's settings can be changed to make it more effective. Look at the settings along the Options bar across the top of the screen.

CREATE A SPOT COLOUR PHOTOGRAPH

Photoshop can convert a colour photograph into a black and white, but leave one or more subjects or objects in colour. The following pages show how to complete this conversion.

SELECT THE COLOURED OBJECTS

The first stage in converting an image to a black and white with a spot colour is to select the objects that need to remain coloured. Whilst many digital cameras can do this by identifying a colour before the photograph is taken, Photoshop is more versatile, because the objects can be selected, so a range of colours can be included. Use the selection tools (Magic Wand, Lasso, Quick Selection) to select the objects that need to remain coloured. The selection tools are covered in greater detail in chapter 1.

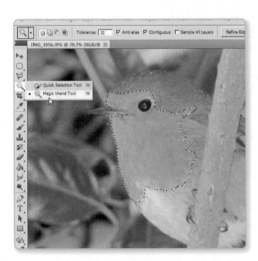

Copy the Selection

After selecting part of the photograph to remain in colour, it has to be copied as a new layer, so click on the Layer menu, select New and choose Layer via Copy from the sub-menu. The selected area will appear as a layer on the right side of the screen in the Layers panel.

Convert to Black and White

Select the background layer from the Layers panel on the right side of the screen. This is the whole image,

Above: Use the selection tools on the Tools toolbar to select a particular object to remain coloured.

Hot Tip

Spot colouring in Photoshop can be used for several objects and a mixture of colours.

but does not include the copied selection. The method of converting to black and white differs between earlier and later versions of Photoshop, and is explained as follows:

→ **Later versions**: Click on the Image menu, select Adjustments and choose Black & White. From the dialogue box that appears, the settings should be sufficient to convert the image to black and white (make sure the Preview box is ticked). If it isn't, check our illustration for the correct settings. Click on OK to close the dialogue box.

→ **Early versions**: Click on the Image menu, select Adjustments and choose Desaturate from the sub-menu. The background layer will be converted to black and white, but the coloured layer will remain on top. This method can be used in all versions of Photoshop.

Flatten and Save

Once the image is complete, it is worth flattening it to reduce

Above: In later versions of Photoshop, click on the Image menu, select Adjustments and choose Black & White.

its file size and save it as a file format such as a JPEG. Click on the Layer menu and choose Flatten Image. Finally, save the image.

CREATE LIGHTING EFFECTS

Professional photographers use expensive lighting equipment and neutral density filters to create artificially lit photographs with dark backgrounds, but Photoshop can recreate these images with its lighting effect filters.

DARKEN AN IMAGE

Photoshop's lighting effects can light specific areas of a photograph and will automatically darken all other areas. If, however, you wish to darken an image yourself, there are two popular methods to make an image look dark, which are as follows:

- **Adjust brightness/contrast**: Click on the Image menu, select Adjustments and choose Brightness/Contrast from the sub-menu. From the dialogue box that appears, reduce the brightness and marginally increase the contrast. This should darken the image.

Above: An image can be darkened using the Brightness/Contrast controls or the Exposure dialogue box.

- **Adjust exposure**: Technically speaking, this is the correct way to darken an image. Click on the Image menu, select Adjustments and choose Exposure from the sub-menu. From the dialogue box that appears, reduce the exposure value and the image will become darker (make sure the Preview box is ticked).

APPLY THE LIGHTING

Click on the Filter menu, select Render and choose Lighting Effects. From the dialogue box that appears, there are several controls that need to be adjusted to create the best effect. These are as follows:

- **Preview screen**: Drag and drop the lighting that has been applied to the image around this small preview screen. Photoshop will automatically add lighting, but this can be dragged to the trash bin to remove it and new lighting added by dragging the light bulb into the image preview screen.

- **Light type**: Click on the drop-down list to choose between a Spotlight, Omni (like a normal light bulb) and Directional (like a flashgun). Each lighting marker in the small preview screen can be changed to these different types of lighting.

Above: Photoshop's lighting effects can lighten specific parts of an image and darken the rest of it.

- **Intensity**: Adjusts the amount of light for a selected light.

- **Properties**: Adjust further settings for all the lighting. The exposure setting can help to further increase or reduce the amount of lighting.

Adjust the Angle and Size of Lighting

The spotlight lighting can be adjusted to alter its angle of direction. This is fiddly and requires the mouse pointer to be positioned over the dots around the spotlight circle. Hold the mouse button down (left button for a PC), then move the mouse to alter the angle. It may take several attempts to successfully adjust the angle. Similarly, the Omni light can be resized by positioning the mouse pointer over the edges of its circles and dragging them in or out.

QUICK TEXT EFFECTS

Artistic effects can be quickly applied to text using a variety of tools in Photoshop, including blending options and filters. The possibilities are limited by imagination only, but the best results are achieved through practice, so try your hand at some of these text effects.

TYPE OF TEXT

Text produced using the Horizontal or Vertical Type Tool (look for the T-shaped button halfway down the Tools toolbar) is created as a separate layer. This enables it to be moved around the image and manipulated separately from other objects.

Above: Blending Options for text can add a number of artistic effects in a few seconds.

Blending Options

Some of the fastest text effects that can be applied concern Blending Options. Look in the Layers panel on the right side of the screen for the layer containing the text. Right click (PC) or Ctrl and click (Mac) on the text, then choose Blending Options from the menu that appears. A large dialogue box will appear with a number of options for adding an effect to the text. Most of the styles listed down the left side of the dialogue box can apply some artistic effects.

Make sure the Preview button is ticked and the effects will be applied immediately.

Filter Effects

Photoshop's Filter Effects can add a variety of artistic effects to text. Click on the Filter menu and choose Filter Gallery. A warning box may appear, asking to rasterize the text. Click on OK to proceed and a new window will appear with several categories of filter and choices

Above: Filters can be applied to text, but a warning box may appear, asking to rasterize the text first.

within each filter. Select one from the list and look at the preview window on the left to see whether the text has changed. If you find a filter you want to apply, select it and click on the OK button, otherwise click on the Cancel button.

Paint Bucket

Click on the Paint Bucket button, halfway down the Tools toolbar on the left side of the screen. It shares its button with the Gradient Tool, so right click (PC) or Ctrl and click (Mac) on this button and choose Paint Bucket Tool from the list that appears. Click on the Set Foreground Color button at the bottom of the Tools toolbar to pick a suitable colour from a dialogue box. Finally, position the mouse pointer over a letter and click inside it to apply the selected foreground colour.

Hot Tip

Press G on the keyboard to switch on the Paint Bucket, but if the Gradient Tool is selected instead, press Shift and G to switch to the Paint Bucket.

REDECORATE A ROOM

Photoshop can be used to realistically change the colour of objects in a photograph, which is useful when considering a new colour scheme for the walls in a room. The following pages explain how to repaint walls without a tin of paint or roller.

Above: A room can be redecorated using Photoshop to experiment with a variety of colours.

SELECT THE WALLS TO REDECORATE

With a suitable photograph of the room open in Photoshop, use one of the selection tools to select the walls to be redecorated. The Quick Selection Tool, Magic Wand, Pen Tool and Polygonal Lasso or Magnetic Lasso can all be used to make a selection. For further details on using these selection tools, see chapter 1. After making the selection, save it by clicking on the Select menu and choosing Save Selection – from the dialogue box that appears, enter a name for the selection and click on OK. Saving the selection will help to return to it in the future.

Hot Tip

Press F7 to show or hide the Layers panel on the right side of the screen.

Left: Use the selection tools to select the walls that will be 'repainted' using Photoshop.

COPY THE WALLS INTO A NEW LAYER

Click on the Layer menu, select New and choose Layer via Copy from the sub-menu. Look at the Layers panel on the right side of the screen and the walls will be displayed in a small thumbnail box as a separate layer. Next, remove the view of the Background layer from the screen by clicking on the eye symbol to the left of it. The selected walls will now be displayed in Photoshop.

Above: The selected walls can be copied as a separate layer to allow them to be redecorated and blended.

CHOOSE A COLOUR FOR THE WALLS

Click on the Set Foreground Color button at the bottom of the Tools toolbar on the left side of the screen. From the dialogue box that appears, choose a colour. These are solid colours, but whichever colour is selected can be altered to look more realistic. Click on OK to close the dialogue box. The selected colour will be displayed on the Set Foreground Color button.

Paint the Walls

Select the Paint Bucket Tool from the Tools toolbar on the left side of the screen. Position the mouse pointer inside the selected walls and it should change to the Paint Bucket symbol. Click with the mouse (left click using a PC mouse) to apply the colour – you may need to click a few times. This won't look particularly realistic yet.

Hot Tip

Adjust the Fill and Opacity values of Layer 1 (see the Layers panel) to alter the colour of the walls.

Above: The layer containing the cut-out walls in a solid colour has to be blended first by changing the Blend Mode from Normal to Color.

Above: Adjust the Hue and Saturation to make the colour change look more realistic.

Blend in the New Colour

Make sure Layer 1 is still selected in the Layers panel on the right side of the screen. The word Normal will be displayed at the top of the Layers panel (this is the Blend Mode). Click on the drop-down list next to the word Normal and choose Color (near the bottom of the list). The new wall colour will now look a little more realistic.

Adjust the Hue and Saturation

The background needs to be displayed to be able to see the redecorated walls, so click inside the empty box to the left of the background's thumbnail (inside the Layers panel). An eye symbol will appear and the photograph will return to the screen with the walls repainted. Make sure Layer 1 is selected from the Layers panel, which contains the cut-out walls in the selected colour. Click on the Image menu, select Adjustments and choose Hue/Saturation from the sub-menu. The Hue and Saturation controls will appear in a dialogue box. Adjust these controls to make the cut-out walls look more realistic (less saturation often works).

Make Further Changes

The colour of the walls can be changed again if necessary by selecting Layer 1 and reusing the Paint Bucket Tool with another foreground colour. Similarly, the Hue/Saturation can be adjusted again. Also, try making other adjustments, such as Brightness/Contrast, which are on the same sub-menu as Hue/Saturation.

ADD A SWIRL AROUND TEXT

Photoshop has a wide assortment of special effects for text, including adding a swirl pattern around text, distortion and a wide range of filter effects. The following step-by-step guide shows how to create a swirl effect around text.

STEP BY STEP

1. Starting with a new file (click on the File menu and choose New) and a white or coloured background (choose a background colour first), select the Brush Tool from the Tools toolbar – right click (PC) or Ctrl and click (Mac) on this button and choose Brush Tool from the list. Choose a size for the Brush Tool using the settings on the Options bar along the top of the screen. Also, choose a colour for the Brush Tool by clicking on the Foreground Color button at the bottom of the Tools toolbar.

2. Position the mouse pointer at the top of the image, hold the Shift key and mouse button (left button for a PC mouse) down, then draw a line down the image. By holding down the Shift key, a straight line is drawn.

Above: A swirl effect can be wrapped around text using a line drawn with the Brush Tool.

3. Click on the Filter menu, choose Distort and select Shear from the sub-menu. From the dialogue box that appears, adjust the settings in the top-left area to convert the line drawn in the last step into a swirl – click on the line to set points and drag them to adjust the swirl.

Above: After drawing a line with the Brush Tool, click on the Filter menu, select Distort and choose Shear to make swirl patterns.

4. With a swirl pattern inside the image, the next stage is to add some text. Right click (PC) or Ctrl and click (Mac) on the Type Tool on the Tools toolbar (there is a letter T on the button) and choose the Vertical Type Tool. Change the settings along the Options bar for the font, size and colour (select a colour that is different from the swirl and background), then click inside the image and type the text.

5. After typing the text, it will probably be the wrong size and in the wrong position. The text is created as a separate layer, so select this layer (usually called Layer 1) from the Layers panel on the right side of the screen (press F7 if it is not visible). Click on the Edit menu, choose Transform and select Scale. A box will appear around the text. Drag and drop the

Hot Tip

Press Shift and B to switch between the different Brush tools.

box to move it and resize the box to resize the text. Press Enter/Return to complete the changes.

6. With the text correctly positioned, the swirl needs to be wrapped around it. First, the image has to be flattened, so click on the Layer menu and choose Flatten Image. The text layer will disappear from the Layers panel on the right side of the screen.

7. The swirl is going to alternate between running over the text and running behind it. At present, all the text is in front of the swirl. To run text behind the swirl, part of the text has to be selected and deleted, replacing it with the colour of the swirl.

8. The foreground colour has to be set to the same colour as the swirl. Click on the Set Foreground Color button at the bottom of the Tools toolbar. From the dialogue box that appears, do not select a colour. Instead, click on the swirl to select its colour, then click on OK.

Above: Click on the Edit menu, select Transform and choose Scale. A box will appear around the text, enabling it to be moved and resized.

Hot Tip

Horizontal text with a swirl effect can also be created by drawing a horizontal line with the Brush Tool and creating text using the Horizontal Type Tool.

9. Right click (PC) or Ctrl and click (Mac) on the Lasso Tool near the top of the Tools
 toolbar. From the list that appears, select Polygonal Lasso. Make your selection around a
 part of the text that should have the swirl running over the top of it. Click on the Edit
 menu and choose Fill. From the dialogue box that appears, select Foreground Color from
 the drop-down list at the top, then click on OK. The selected part of the text will now be
 hidden by the swirl.

10. Continue selecting parts
 of the text to fill with the
 foreground colour (the
 swirl colour). Try to
 alternate, so the swirl runs
 in front and behind the
 text. When the image is
 complete, it may help to
 crop it, especially if it is
 going to be used
 elsewhere in another
 image or on a website.
 Press C to switch on the
 Crop Tool or select its
 button from the Tools
 toolbar on the left side of
 the screen.

Above: After positioning the text, flatten the image, then select parts of
the text and fill with the same colour as the swirl.

Hot Tip

In later versions of Photoshop, select an area of an image and press **Delete** on the
keyboard to automatically open the **Fill** dialogue box and apply a fill colour.

ADD A RAINBOW TO A SKY

A cloudy sky with the sun shining behind or through it can be further enhanced by adding a rainbow. The following step-by-step guide shows how to create an artificial rainbow using Photoshop's Gradient Tool and Gaussian Blur.

STEP BY STEP

1. Open a suitable image in Photoshop to add a rainbow to the sky. Ideally, an image with a cloudy but sunlit sky is suitable. The first step is to create a new layer to construct the rainbow, so click on the Layer menu, choose New and select Layer from the sub-menu. A dialogue box will appear – note the name of the layer, make sure there is no colour applied and make sure the opacity setting in the dialogue box is set at 100% before clicking on OK.

2. With the new empty layer created, select the Gradient Tool button, halfway down the Tools toolbar. This button is shared with the Paint Bucket Tool, so you may need to right click (PC) or Ctrl and click (Mac) on the button and choose Gradient Tool from the list that appears.

3. After selecting the Gradient Tool, click on the drop-down palette of gradient colour schemes on the Options bar across the top of

Above: A rainbow can be added to a scenic photograph using the Gradient Tool and adding a special effect called Russell's Rainbow.

the screen. The required scheme is called Russell's Rainbow, but may need to be added. If it is not visible, click on the small triangle at the top right of the palette of schemes and a shortcut menu will appear. Select Special Effects from the menu.

4. Upon selecting Special Effects from the shortcut menu, a warning message box will appear. Click on the Append button. Return to the palette of Gradient schemes and select Russell's Rainbow. Also, select the Radial Gradient button along the Options bar – this will enable a circular-shaped rainbow to be drawn.

5. You are now ready to draw a rainbow with the Gradient Tool set to Russell's Rainbow using a Radial Gradient. The rainbow is drawn as a circle. Click inside the image to select the centre point of the circle and click elsewhere to select the outer edge of the circle. Consequently, by clicking at the edge of an image and then somewhere inside, a semicircle is created.

6. The rainbow won't look very effective, but it can be improved. First, right click (PC) or Ctrl and click (Mac) on the new layer (usually called Layer 1) in the Layers panel on the right side of

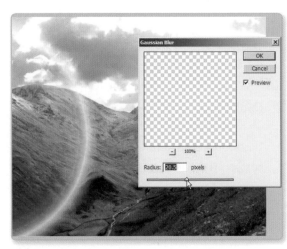

Above: Applying a Gaussian Blur can help to blur a rainbow and make it look more realistic.

Hot Tip

Switch on the Gradient Tool by pressing Shift and G on the keyboard –
this will switch between this tool and the Paint Bucket.

the screen and choose Blending Options. From the dialogue box that appears, click on the drop-down list for Blend Mode and change it from Normal to Screen. Next, click on the Filter menu, choose Blur and select Gaussian Blur. With the Gaussian Blur dialogue box open, adjust the radius to blur the rainbow and make it look more realistic. Click on OK to return to the image.

Hot Tip

Press Ctrl (PC) or Command (Mac), and J, to create a copied layer.

7. There will probably be some unwanted parts of the rainbow, so these can be removed by adding a layer mask and using the Gradient Tool again with a different colour scheme. First, make sure Layer 1 is still selected in the Layers panel, then look for a button at the bottom of the panel called Add Layer Mask (it looks like a white circle). Click on it once and a white box will appear next to Layer 1 in the Layers panel.

8. Make sure the Gradient Tool is still selected, then return to the palette of colour schemes in the Options bar. Choose the black and white option, then click on the Linear Gradient button in the Options bar. Adding a black and white gradient allows the brightness of the rainbow to be altered and parts of it removed.

Right: Unwanted parts of the rainbow can be removed by drawing a line using the Gradient Tool with a black and white colour scheme.

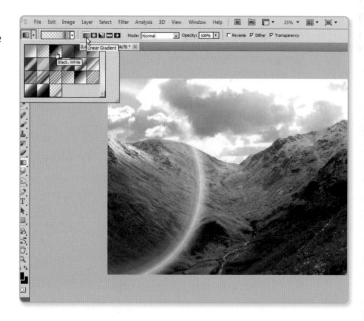

9. Position the mouse pointer inside the image, near the rainbow, and click once, then move the mouse pointer to a different part of the rainbow and click again. The second click sets the brighter point of the rainbow and the first click sets its duller point. You will probably need to click on the Edit menu and choose Undo, then try this again, to find the correct method of removing an unwanted part of the rainbow.

> ## Hot Tip
> Hold the Shift key down when using the Gradient Tool to draw a vertical or horizontal line.

10. If the rainbow now looks too weak, duplicate the layer containing it by clicking on the Layer menu, choosing New and selecting Layer via Copy. A copy of the layer and mask will appear in the Layers panel. Check the opacity setting for each layer is 100% (look above the list of layers for this setting).

11. When the image looks complete, click on the Layer menu and choose Flatten Image, then save the file with a different name to the original.

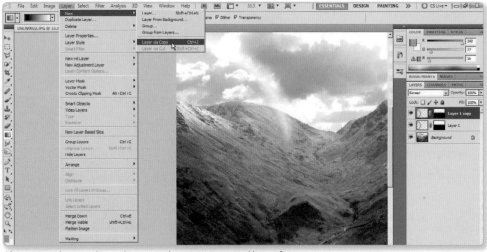

Above: A rainbow can be made stronger by creating a copied layer of it.

MAKE A MINIATURE SCENE

Photoshop can make an image of a real-world scene look as though it is in miniature, transforming a photograph of a village or train station into a model. The following pages show what is involved in this conversion using Photoshop.

SUITABLE IMAGES

Not all images can be successfully converted to look like the contents are from a miniature village or set of scaled-down plastic models. Scenes with buildings, transport and people in the distance can often work, but the method involves creating a narrow depth of field where only the background or foreground is in focus.

Above: This view of a campsite and theme park taken from a Ferris wheel can be altered in Photoshop to look like a model village scene. The original image is in the top-right corner.

Switch on Quick Mask Mode

Once a suitable image has been opened in Photoshop, the first stage is to edit it using the Quick Mask Mode. This will help to mask over the changes that need to be applied to it. At the bottom of the Tools toolbar on the left side of the screen, there is a button that looks like a rectangle with a circle inside it. Its exact position varies between different versions of Photoshop, but it is near the bottom of this toolbar and switches on the Quick Mask Mode. Click on this button to activate this. The filename of the image displayed on the screen may have the words Quick Mask displayed alongside it.

Hot Tip

Press Q on the keyboard to switch the Quick Mask Mode on and off.

Below: The miniaturizing effect can be applied to shots of natural as well as man-made landscapes.

Use the Gradient Tool

Right click (PC) or Ctrl and click (Mac) on the Gradient Tool or Paint Bucket Tool in the middle of the Tools toolbar on the left side of the screen. From the list that appears, select Gradient Tool. Next, look at the buttons along the Options bar across the top of the screen and find the button for a Reflected Gradient or Cylindrical Gradient and click on it. Hold the Shift key down and draw a line from the point in the image that needs to remain in focus to the backdrop that will be out of focus. A red haze will appear over the image.

Quick Mask Off and Blur

Switch off the Quick Mask Mode by clicking on the relevant button or by pressing Q on the keyboard. A dotted line will appear across the image, signifying a mask. Now, it is time to add some blur, so click on the Filter menu, choose Blur and select Lens Blur. From the window or dialogue box that appears, adjust the radius, brightness and threshold values. Make sure the Preview box is ticked and, if the wrong part of the image is out of focus, add or remove a tick mark in the Invert option. Click on OK to return to the image, then click on the Select menu and choose Deselect.

Left: Using the Lens Blur window and switching the Invert tick box on or off enables the foreground or background to be out of focus. This edited photograph is taken from the Petronas Towers in Kuala Lumpur.

Hot Tip

Press C on the keyboard to switch on the Crop Tool.

Increase Saturation

The model look to a photograph can be further enhanced by increasing its saturation to give it a more plastic look. Click on the Image menu, select Adjustments and choose Hue/Saturation from the sub-menu. When the dialogue box appears, increase the saturation value to around 40 and see if this alters the image. Similarly, adjust the lightness figure to see if it makes a difference.

Above: The model effect renders people and objects 'plasticky'.

Left: Adjusting the saturation and lightness can help to further enhance the model-village look to this photograph that was originally taken overlooking the business district in Kuala Lumpur.

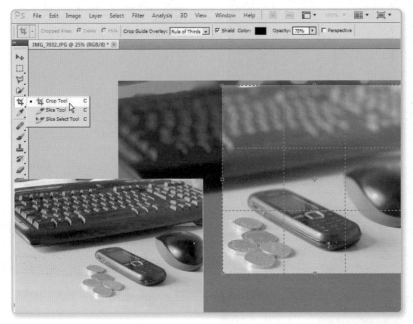

Left: Cropping an image after it has been miniaturized can help to make it look more effective.

Below: A narrow depth of field can lend a more professional look to a photograph.

Cropping

Try cropping an image to increase its miniature effect. This can help to exclude objects that don't look small, even after editing. The Crop Tool is on the Tools toolbar on the left side of the screen. Cropping is covered in greater detail in chapter 1.

Other Uses for the Miniature Effect

Photoshop's miniature magic is not reserved solely for scenic photographs. Photographs of food can be transformed into professional images with a narrow depth of field using the techniques outlined in this section. Objects can also be miniaturized or emphasized in a photograph by keeping them in focus.

ADVANCED PHOTOSHOP SUBJECTS

CUT OUT AN OBJECT

Objects within images can be cut out in Photoshop to produce separate images with different-coloured backgrounds. This is useful for images of products and to build up a library of object images to use elsewhere.

ERASE THE BACKGROUND

The Eraser Tool can be used to remove parts of an image, which can help with cutting out an object. There are three different types of Eraser Tool, which are all found on the

Hot Tip

Press Shift+E to switch between the different Eraser Tools.

respective toolbar button, halfway down the Tools toolbar on the left side of the screen. These include the standard Eraser, the Background Eraser and the Magic Eraser. To choose one of them, right click or Ctrl and click on the Eraser Tool button and a list of all three tools will appear for you to select from.

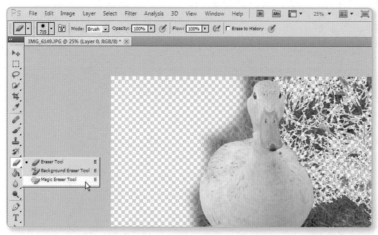

Left: The Eraser tools can be used to remove a background from an image.

Standard Eraser Tool

The normal Eraser Tool can remove parts of an image using a variety of brushes, a block or a pencil. There are a number of settings for this Eraser Tool, which are displayed along the Options bar across the top of the screen. To begin erasing, position the mouse pointer inside the image, hold the mouse button down (left button on a PC mouse) and swipe across the image. The Eraser Tool also works by single clicking.

Hot Tip

Adjust the opacity to 100% to completely remove objects from an image using one of the Eraser tools.

Background and Magic Eraser Tools

Both of these tools remove parts of an image according to whatever has been selected. The Background Eraser changes the mouse pointer to a small cross and a circle. Position the cross over part of the image to erase. Only the area inside the circle will be erased (the size of the circle can be changed), and only the parts that are the same colour as whatever the cross is positioned over. The Magic Eraser Tool is similar to a Magic Wand Tool. It removes anything in an image that's a similar colour to whatever has been clicked upon. Both of these eraser tools have tolerance settings to allow a wider or narrower range of colours to be erased based on whatever the mouse pointer clicks on.

Eraser Tools Mistakes

It is important to watch what the Eraser tools select: if the wrong part of the image is selected, the action needs to be reversed by clicking on the Edit menu and selecting Undo. If several actions need to be reversed, return to the Edit menu and choose Step Backward (this can be done several times).

Above: Erasing mistakes can be reversed using the Undo and the Step Backward commands on the Edit menu.

Saving a Part-erased Image

An image that has been cut out using the Eraser tools can be saved as a Photoshop PSD file to allow various Photoshop-specific settings to be retained (useful if you want to return to editing the image). Otherwise, it can be saved as a JPEG and will appear with white sections for the areas that have been erased.

CUTTING OUT WITH A SELECTION TOOL

Photoshop's selection tools, including the lassos, marquees, Magic Wand Tool and Quick Selection Tool, can all help to cut out an object from an image. Removing some or all of the background using the Eraser tools can help some of the selection tools to avoid choosing the wrong parts of the image. The selection tools are covered in greater detail in chapter 1, pages 41–56.

Cut Out and Copy to a New Layer

After selecting an object using the selection tools, it may help to copy it into a new layer, then delete the original layer. With the object selected, click on the Layer menu, select New and choose Layer via Copy from the sub-menu. A new layer will appear in the Layers palette on the right side of the screen (press F7 if it cannot be seen). Select the original layer from this palette and press Delete on the keyboard to remove it. The image can now be saved as a Photoshop PSD file to enable further editing, or as a JPG with a white background.

Above: An object can be cut out of an image by selecting it, then creating a new layer from it.

COLOUR THE BACKGROUND

An erased area can be coloured using the Paint Bucket Tool on the Tools toolbar (halfway down the toolbar). After selecting it, click on the Set Foreground Color button at the bottom of the Tools toolbar and select a colour to use from the dialogue box that appears, then click on OK. Position the mouse pointer inside the erased area, then click once (left click with a PC mouse) to apply the colour. If the colour covers part of the image, undo this action, then select the area to colour in using the selection tools before applying the colour.

Hot Tip

Press Ctrl (PC) or Command (Mac), and J, to create a new layer via copy.

Select and Inverse

The erased area of an image can be selected by first selecting the object inside the image, then clicking on the Select menu and choosing Inverse. Everything but the object that was selected will now be selected.

Left: The background for a cut-out object can be coloured using the Paint Bucket Tool.

IMAGE SECURITY

When the ownership of images including artwork and photographs needs to be preserved, Photoshop has a number of useful features that can help to keep them secure and free from being copied, including watermarks, digital watermarks and password protection.

ADD WATERMARK TEXT

One of the easiest methods of adding a watermark to an image is to add some text to it, then reduce its opacity to let the image show through it. First, click on the Horizontal or Vertical Type Tool button on the Tools toolbar (left side of the screen, halfway down the toolbar). There are a number of buttons for typing text, so position the mouse pointer over the button (it looks like a letter T), hold the mouse button down (left button for a PC mouse) and wait for a list to appear before selecting either the Horizontal or Vertical Type Tool.

Left: Text can be displayed over an image to resemble a watermark. Click on the Horizontal or Vertical Type Tool to create the text.

Set the Font, Size and Colour

After selecting the Horizontal or Vertical Type Tool, the font, size and colour can be changed using the settings along the Options bar across the top of the screen. If the image contains dark colours, for instance, consider using a light font, such as yellow or white. These settings can be changed whilst typing the text, so click inside the image and begin typing. Notice the text appears as a separate layer in the Layers panel on the right side of the screen.

Move the Text

Once the text has been typed, click on the Move Tool or press V on the keyboard to switch it on. Select the layer containing the text from the Layers panel on the right side of the screen. Position the mouse pointer over the text inside the image, then drag and drop it.

Rotate the Text

A watermark often looks more effective if it appears diagonally across an image, so make sure its layer (the text) is selected from the Layers panel on the right side of the screen, then click on the Edit menu, select Transform and choose Rotate from the sub-menu. A box will appear around the text. Position the mouse pointer around the outside edge of the box. When the mouse pointer changes to a semicircular double-headed arrow, hold the mouse button down (left button for a PC mouse) and move the mouse to rotate the text. Press Enter/Return to complete the changes, or Escape to reject them.

Above: The text can be rotated by clicking on the Edit menu, choosing Transform and selecting Rotate from the sub-menu.

Reduce the Opacity

The transparency (opacity) of the text needs to be reduced to allow the image to be seen through it. Select the layer for the text in the Layers panel on the right side of the screen. Just above the selected layer, there is an opacity setting, which is usually set to 100%. Reduce this value to around 30–40% and see if the image can be seen through the text.

> **Hot Tip**
>
> **Reducing the Fill value (next to Opacity) can also fade text and help create a watermark.**

Edit or Delete the Text

If the text needs to be edited, select the Type Tool button again, along with the relevant layer from the Layers panel on the right, then click inside the text. A flashing cursor will appear inside the text and it can now be changed. If all the text needs to be removed, right click or Ctrl and click on the text's layer in the Layers panel. From the shortcut menu that appears, select Delete Layer – a message box will appear asking to confirm removal of the layer.

Flatten and Save

To complete the watermark, click on the Layer menu and choose Flatten Image, then save the file. This will ensure the text cannot be removed, as it is no longer stored as a layer.

DIGITAL WATERMARKS

Most versions of Photoshop have a plug-in by Digimarc (see www.digimarc.com), which allows a watermark to be displayed and ownership information to be stored with an image.

>
>
> **Hot Tip**
>
> **Check a digital watermark by clicking on the Filter menu, selecting Digimarc and choosing Read Watermark from the sub-menu.**

This can be applied to an image in Photoshop by clicking on the Filter menu, selecting Digimarc and selecting Embed Watermark. From the dialogue box that appears, choose any of the available options and click on OK. A second box will appear with a summary of the watermark settings. Click on OK to apply these settings.

Above: A digital watermark provides greater security over images than adding some text to them.

SAVE A PDF WITH A PASSWORD

Photoshop can save an image as a Photoshop PDF, which can include password protection. Click on the File menu and choose Save As. From the dialogue box that appears, click on the drop-down list for the file format or type and choose Photoshop PDF. Enter a name for the file and click on the Save button.

A small warning box may appear advising that the settings you choose in the Save Adobe PDF dialogue box may change the settings in the Save As dialogue box – click on OK. Another dialogue box will appear with various options. Choose Security from the list on the left and a number of password options will be displayed.

Right: Saving a file as a Photoshop PDF allows a password to be set to prevent unwanted editing and to restrict who can open the image.

HOW DO THEY DO THAT?

There are a wide variety of effects and imagery that have been created or can be re-created in Photoshop. The following pages provide some examples of professional images and how they can be reproduced in Photoshop.

STATIONERY ARTWORK

The quill card pictured here was created by Swann of York (www.swannofyork.com) using scanned images, which are resized by clicking on the Edit menu, choosing Transform and selecting Scale. They are also tinted using the Opacity setting in the Layers panel before being cut out using the Magic Wand and transferred to Quark Express to create the final quill card.

TRACKING SHOTS

There was a time when an action shot of a car being driven was usually taken by driving alongside it in another car. Now, Photoshop can take a still image of a car on a road with someone in the driver's seat and convert it to look as though the car is moving. The action photographs shown on these pages were all produced from still images. Two different methods were used to create them, which are described in the following sections.

Right: Paul Swann from Swann of York uses Photoshop to produce the artwork shown on this quill card.

Head-on Action

Where the front of a car looks as though it is driving towards the camera and about to jump off the page, everything in the image except the car has been selected and a zoom blur applied. This can be found by clicking on the Filter menu, selecting Blur and choosing Radial Blur. From the dialogue box that appears, choose the Zoom option and set the Amount to 15–20. This filter effect produces some hazy edges around the car, which will need to be removed with the Clone Stamp Tool.

Erasing Zoom Blur

Another approach to applying Radial Blur for a head-on action shot is to first create a copy layer, then apply the Radial Blur to this layer and choose the Zoom option. With a blurred copied layer and a background layer in focus (the original layer), use the Eraser Tool to remove the blurred parts that need to be in focus (the car).

Above: This article from *Kit Car* magazine shows a Lamborghini Countach replica driving towards the camera. The inset photograph to the left, which was not included in the article, is the actual, unedited image.

Above: The front-cover photograph for this classic car magazine started as the still image on the left. Photoshop's Radial Blur was used with the Zoom option selected to create the motion effect around the car, then the Eraser Tool restored the car.

How to Do It

The beginning of chapter 5 covers the various methods of creating action shots from stills and includes step-by-step guides to help.

PANNING SHOTS

An action shot taken of the side of a subject whilst it is travelling is known as a panning shot and is traditionally taken with a camera. The subject is followed through the camera's viewfinder as it passes by. When the photograph is taken, the camera continues to move and track the subject, so it remains in focus, but the background consequently becomes blurred (a suitable shutter speed is essential). This type of photograph takes practice to perfect, but Photoshop can provide equally impressive results with a still image.

Select and Motion Blur

Use a still photograph taken from the side of a subject, which is composed to make it look as though it is moving. In our example, the car was photographed from the side with someone sitting in the driver's seat, but the car was stationary. Next, select the background using one of the selection tools (Lasso, Magic Wand, Quick Selection), then click on the Filter menu, select Blur and choose Motion Blur. From the dialogue box that appears, set the blur values and angle accordingly, then click on OK.

Left: The photograph shown in this issue of *Car Mechanics* magazine started as a still image taken with the camera next to the car. The Motion and Radial Blur tools were used to blur the background and spin the wheels.

Spin the Wheels

The wheels in our illustration were made to look as though they were rotating by selecting them, then clicking on the Filter menu, selecting Blur and choosing Radial Blur. From the dialogue box that appears, select the Radial option and adjust the Amount value to between 10 and 20, then click on OK.

DANNY BURK'S LAYERS AND MASKS

Danny Burk is a professional photographer living in Indiana in the USA and has been interested in photography since 1973. His website at www.dannyburk.com includes information on his photographic services and workshops, plus advice on how he edited the image of woodland shown here to improve its finish. Danny used a scanned image from a 4-x-5 large-format camera. He created a layer mask from an adjustment layer and altered the tonality, saturation and colour balance.

Right: Danny Burk edited this image taken with a large-format camera using a layer mask in Photoshop and adjusting the tone, saturation and colour balance.

ADVANCED IMAGE IMPROVEMENTS

There are a wide variety of methods for improving an image, which were largely covered in chapter 2 of this book, but many professionals have their own tricks of the trade. The following pages reveal some of their secrets to creating stunning images.

HIGH PASS FILTER

Photoshop's High Pass Filter, along with some layer copying, blending modes and adjustments to shadows and highlights, can help to sharpen and improve an image. The first stage in this transformation is to open the image in Photoshop and make a copied layer by clicking on the Layer menu, selecting New and choosing Layer via Copy from the sub-menu. Look at the Layers panel on the right side of the screen – a new Layer 1 will be displayed.

Left: The High Pass Filter, some different blending modes and adjustments to the highlights and shadows can transform this hazy image of a frog.

Where Is the High Pass Filter?

After creating a duplicate layer, make sure it is selected from the Layers panel on the right side of the screen, then click on the Filter menu, select Other and choose High Pass from the sub-menu. A High Pass dialogue box will appear. Change the Radius value to between four and six pixels, then click on OK. The image will have now changed to grey – this is okay. With Layer 1 still selected in the Layers panel, click on the drop-down list for its Blend Mode (usually set at Normal) and choose Hard Light. The image will return to normal.

Above: After creating a duplicate layer, open the High Pass Filter dialogue box and set the Radius value to between 4.0 and 6.0 pixels.

Copy the Layer

Make sure Layer 1 is selected from the Layers panel on the right side of the screen, then click on the Layer menu, choose New and select Layer via Copy from the sub-menu. A copy of Layer 1 will be created and you may notice the image is now a little sharper.

Copy the Background

Select the Background layer (the original image) from the Layers panel, then copy it via the Layer menu (click on the Layer menu, choose New and select Layer via Copy). Change the Blend Mode of this copied layer to Screen – click on the drop-down list above the layer in the Layers panel and change the Blend Mode setting from Normal to Screen.

Erase Light and Dark Patches

If there are any areas in the image that are too light or too dark, these can often be removed using the Eraser Tool.

Hot Tip

Press E on the keyboard to switch on the Eraser Tool.

Select this button from the Tools toolbar (about halfway down) and swipe over light or dark areas of the image with the mouse button held down (left button for a PC mouse). This effectively removes areas of the image from the background copy layer, but keeps the image in the other layers.

Above: The Eraser Tool can be used to lighten and darken areas of the photograph using a copy of the background layer.

Flatten and Adjust Shadows and Highlights

Click on the Layer menu and choose Flatten Image. All of the layers will disappear from the Layers panel, leaving just the background. Finally, click on the Image menu, select Adjustments and choose Shadows/Highlights from the sub-menu. From the dialogue box that appears, adjust the settings and see if this can further improve the image (make sure the Preview box is ticked to check the changes instantly).

Above: Adjusting the shadows and highlights can help improve an image. Make sure the Preview box is ticked to check each alteration.

> ## Hot Tip
>
> **An alternative approach to using the High Pass Filter is to use the Unsharp Mask, which is covered in chapter 2 (see Fix an Out-of-focus Photograph, page 87).**

COLOUR CORRECTION WITH CURVES

Many professionals prefer to use Photoshop's Curves to colour-correct an image and ensure the right balance of colours is used. To understand curves, it is essential to know a little about RGB images and what they represent. In brief, RGB stands for Red, Green and Blue, which covers the full range of colours of the rainbow (red, orange, yellow, green, blue, indigo and violet) to make up white light. In the case of RGB, these are the base colours to create an image and can be adjusted using Photoshop's Curves to apply more or less of these colours.

Where are Curves?

Photoshop's Curves can be found on the Image menu by selecting Adjustments and choosing it from the sub-menu that appears. However, it is always good practice to make such adjustments using a separate layer, so, instead, click on the Layer menu, choose New Adjustment Layer and select Curves from the sub-menu. A New Layer dialogue box will appear. Click on OK and the Curves settings will appear in the panel on the right side of the screen.

Hot Tip

If an adjustment to the Curves doesn't work, click on the Edit menu and choose Undo.

Correct Colour Correction

There are a number of methods for successful colour correction using Photoshop's Curves. The following information explains how these are used:

- → **Adjust the curve chart**: Drag the line in the chart to adjust the colour settings. This can often be instantly successful if you find the right settings.

- → **Select a dropper**: There are three droppers for Curves, allowing the selection of black, white and a mid-grey colour. Click on one of these droppers, then click on part of the image that should represent that colour (for example, a white part). The image's curves will be automatically adjusted.

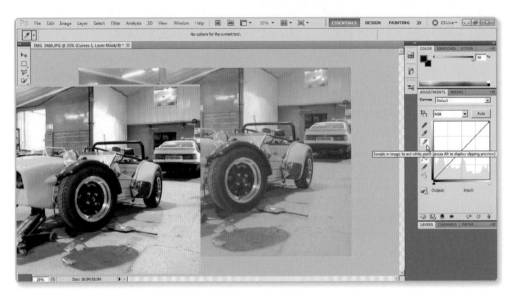

Above: This photograph was taken under artificial lighting and looks far too orange (through too much yellow overall). Making colour corrections using Curves helps to remove the colour cast.

→ **Individual RGB:** Click on the drop-down list for RGB and choose the individual colours for Red, Green or Blue, then adjust the chart for each colour to see if this helps to reduce or increase each colour.

EDITING WITH ADJUSTMENT LAYERS

Adjustments including Hue and Saturation, Brightness and Exposure are often more effective if they are made in a separate layer. Not only does this enable each adjustment to be mixed and its opacity adjusted, but it also enables part of a layer to be adjusted by erasing the rest of it.

Creating an Adjustment Layer

If you want to alter the brightness, contrast or make any other adjustments which are on the Image menu under Adjustments, then a separate layer for each adjustment can be made by clicking on the Layer menu, choosing New Adjustment Layer and selecting one of the

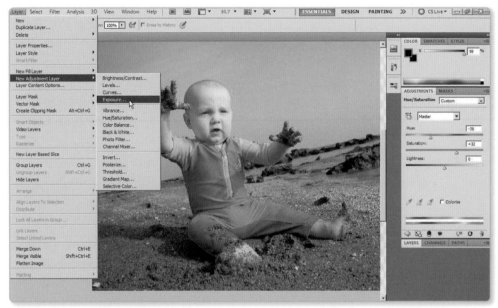

Above: Gain greater control over adjustments such as brightness, contrast, exposure and levels by creating each one as an adjustment layer.

adjustments from the sub-menu. For each adjustment that is selected from this sub-menu, a separate layer is created and listed in the Layers panel on the right side of the screen.

Making Adjustments

After creating a new adjustment layer, the adjustment controls, such as Brightness and Contrast, are displayed on the right side of the screen where the Layers panel is located. There is an Adjustments tab here, so each adjustment layer can be altered by selecting its layer, then clicking on the Adjustments tab.

Controlling Adjustments

Whilst the settings for an adjustment such as Exposure or Brightness and Contrast allow the image to be adjusted, the Opacity and Fill settings above the list of layers in the Layers panel can also help to control how much effect the adjustment layer has on the overall image.

Above: Part of an adjustment layer can be included in an image by removing sections of it with the Eraser Tool.

Part Erasing an Adjustment Layer

If half of an image is too bright, then adjusting the brightness of the entire image won't help. Instead, create a Brightness/Contrast Adjustment layer, alter the brightness to suit the bright part of the image (the other half will probably become too dark), then use the Eraser Tool to remove the dark part of the adjustment layer. The Eraser Tool is halfway down the Tools toolbar on the left side of the screen. You may need to right click (PC) or Ctrl and click (Mac) on the button and choose Eraser Tool from the list, because it shares its button with other tools, including the Magic Eraser Tool.

Remove an Adjustment Layer

An adjustment layer can be quickly removed by selecting it from the Layers panel and pressing Delete on the keyboard. If this doesn't work, right click (PC) or Ctrl and click (Mac) on the name of the adjustment layer in the Layers panel and choose Delete Layer – a warning box may appear asking to confirm deletion.

Don't Forget to Flatten

Once an image has been sufficiently edited, merge all the layers by clicking on the Layer menu and choosing Flatten Image. This will help to reduce its file size.

Hot Tip

Adjust the size of the Eraser Tool by right clicking (PC) or Ctrl and clicking (Mac) inside the image.

MASKS

Photoshop masks are an essential part of image editing and require a thorough understanding if you want to progress and become an advanced user. The following pages give an overview of what masks are and how they should be used.

WHAT IS A MASK?

A mask in Photoshop can best be described as a method of selecting part of an image to make changes to it. It originates from the rubylith film that artists use to mask over an image for retouching it.

Above: Most colour images are made up of four channels, which can be seen in the Channels panel on the right side of the screen. From here, a channel mask can be created and its colours edited.

Types of Mask

There are a number of different types of mask, which often makes the subject more confusing than it needs to be. Here are some of the commonly used masks:

Above: The Quick Mask Mode can be switched on and off by clicking on its button at the bottom of the Tools toolbar.

➔ **Quick Mask Mode**: This is one of the most popular masks, as it is quick and easy to create and allows similarly quick editing. It is particularly useful for selecting parts of an image and is fully explained in the next section.

➔ **Layer mask**: Enables parts of a layer to be edited and either hidden or shown. This can be applied to a layer, but not to the background of an image. A layer mask allows editing of a layer without destroying the original image.

➔ **Vector mask**: Whilst a layer mask allows parts of a layer to be hidden or shown, it is created in grayscale. A Vector mask allows colour to be added and a wider range of shapes to be created. A Vector mask can be added to a layer mask.

➔ **Channel mask**: An image has four channels, which are listed in the Channels panel on the right side of the screen (RGB, Red, Green and Blue). New channels called Alpha Channels can be added here and colour changes made to them. This is useful for editing an entire image or a selection.

➔ **Type mask**: Used for creating text where an image is displayed inside the letters. This was covered as a step-by-step guide in chapter three (*see* Adding Text to Images, page 109).

➔ **Clipping mask**: This type of mask allows the content of a layer to mask the layers above it. The masking of the bottom or base layer dictates the masking for all other layers above it.

USING THE QUICK MASK MODE TO MAKE A SELECTION

Whilst the selection tools, including the Lasso (including Polygonal and Magnetic), Magic Wand and Marquee tools, are useful for selecting objects in an image, the Quick Mask Mode can, in some cases, be quicker and more accurate. The Quick Mask Mode can be used alongside one of the selection tools. So, after roughly selecting part of an image, click on the Quick Mask Mode button on the Tools toolbar and everything in the image that has not been selected will be a shade of red. Alternatively, click on the Layer menu and select Edit in Quick Mask Mode.

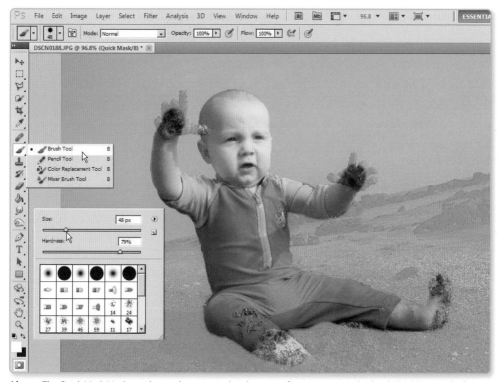

Above: The Quick Mask Mode can be used to accurately select part of an image using the Brush Tool (see overleaf).

Select and Deselect in Quick Mask Mode

A selection can be altered in Quick Mask Mode using the Brush Tool. First, select this button from the Tools toolbar, then right click (PC) or Ctrl and click (Mac) inside the image to set the size of it. The Quick Mask Mode works in grayscale, so setting the Brush Tool's foreground colour to black or white will do the following:

Hot Tip

Press Q on the keyboard to switch the Quick Mask Mode on and off.

➔ **Black**: Remove part of the selection if you click inside the image where it is not shaded red.

➔ **White**: Add to the selection if you click inside the image where it is shaded red.

Switching between Black and White

There is no need to change the colour when selecting and deselecting with the Brush Tool in Quick Mask Mode. Instead, click on the tiny button that looks like a bent double-headed arrow to switch the foreground and background colours round from black to white or vice versa. Alternatively, press X on the keyboard to switch the foreground and background colours.

Return to the Selection

After making some adjustments to the selection in Quick Mask Mode using the Brush Tool, switch off Quick Mask Mode – the red shading will disappear and a series of dotted lines will appear around the selected part(s) of the image.

Hot Tip

If you accidentally change the foreground colour when using the Brush Tool, press D to return it to the default black and white settings.

PHOTOSHOP SHORTCUTS

Photoshop has a varied number of shortcuts using the keyboard and mouse, which are often only discovered by accident, so the following pages provide a checklist of some of the most useful time savers.

MAKING A SELECTION

- **Add to the selection**: Hold down the Shift key and continue clicking around the image to include more of it in the selection.

- **Remove from the selection**: Hold down the Alt (or 'Option') key and click inside the selection to remove part of it.

NAVIGATING INSIDE AN IMAGE

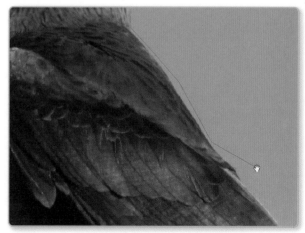

- **Move around**: Hold down the spacebar and drag with the mouse to move the view of the image. This is the same as switching on the Move Tool, but, unlike the Move Tool, it allows the image to be moved when selecting part of it.

- **Zoom in/out (keyboard)**: Hold down the Ctrl (PC) or Command (Mac) key and press plus (+) to zoom in or minus (–) to zoom out.

Above: When selecting part of an image, if you need to scroll down or across the screen, hold the spacebar down and drag the mouse, then release the spacebar and continue selecting.

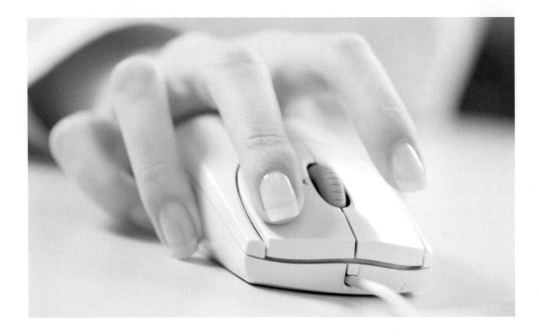

Alternatively, press Z on the keyboard to switch on the Zoom button on the Tools toolbar, then click inside the image (the mouse pointer will be a magnifying glass with a plus symbol inside it) to zoom in, or hold down the Alt key and click inside the image to zoom out.

➔ **Zoom in/out (PC)**: Hold down the Alt key and rotate the scroll wheel of the mouse to zoom in or out.

SCREEN CONTROLS

➔ **Hide the toolbars and panels**: Press the Tab key on the keyboard to hide and reveal the toolbars and panels, then press the Tab key again for them to return.

➔ **Full screen**: Press F on the keyboard to switch to a full screen without menus and toolbars and back again.

TOOLS

➡ **Move**: Press V.

➡ **Rectangular and Elliptical Marquee**: M to activate one of them, or Shift and M to switch between them.

➡ **Lasso**: L to activate one of the Lasso tools, or Shift and L to switch between them.

➡ **Magic Wand**: W. In later versions of Photoshop, the Magic Wand shares the same button as the Quick Selection Tool, so pressing W may select this instead. Press Shift and W to switch between them.

➡ **Crop**: C to activate one of the cropping tools, or Shift and C to switch between them.

➡ **Eye Dropper**: I to activate the Eye Dropper, Colour Sampler and other tools, or press Shift and I to switch between them.

➡ **Healing Brush**, **Patch and Red Eye**: J to activate one of them, or Shift and J to switch between them.

Above: Hover the mouse pointer over a button on the Tools toolbar and its name will appear, along with the keyboard shortcut in brackets.

Above: Right click or Ctrl and click on one of the buttons on the Tools toolbar and a menu lists all options for that button.

Hot Tip

In later versions of Photoshop, click on the two triangles at the top of the Tools toolbar to display the buttons in one or two columns.

- **Brush and Pencil tools**: Press B to switch on one of them, or Shift and B to switch between them.

- **Clone and Pattern Stamp**: S to activate one of them, or Shift and S to switch between them.

- **History and Art History**: Y to activate one of them, or Shift and Y to switch between them.

- **Eraser and Magic Eraser**: E to activate one of them, or Shift and E to switch between them.

- **Paint Bucket and Gradient Tool**: G to activate one of them, or Shift and G to switch between them.

- **Blur, Sharpen and Smudge, or Rotate**: On older CS versions, use R to activate Blur, Sharpen or Smudge, or Shift and R to switch between. In CS5, R is for the Rotate Tool.

- **Dodge, Burn and Sponge**: O to activate one of them, or Shift and O to switch between them.

- **Pen Tool**: P to activate the Pen Tool or Freeform Pen Tool, or Shift and P to switch between them.

- **Type Tool**: T to activate one of the Type tools for creating text, or Shift and T to switch between them.

- **Path/Direct Selection**: A to activate either the Path or Direct Selection Tool, or Shift and A to switch between them.

- **Shapes**: U to activate one of the Shape tools (rectangle, ellipse, polygon), or Shift and U to switch between them.

- **Hand Tool**: H to activate the Hand Tool to move around an image (after zooming into it) and in later versions of Photoshop, press Shift and H to switch between this and the Rotate View Tool.

- **Zoom**: Z to switch on zooming into an image. Hold down the Alt key and click inside the image to zoom out.

RIGHT CLICK OR CTRL+CLICK

Some of the most useful features of Photoshop are its context-sensitive menus and option boxes that appear when you right click (PC) or Ctrl and click (Mac) with the mouse. There are a number of uses, which are outlined as follows:

- **Size and hardness box**: The Clone Stamp, Eraser, Healing brushes, Smudge/Dodge/Burn and other tools whose size, hardness and other settings can be changed all have a settings box that appears upon right clicking or Ctrl and clicking inside the image.

- **Tools toolbar buttons**: Right click or Ctrl and click on any of the buttons on the Tools toolbar that share a number of different buttons and a list of these different buttons will appear.

- **Scroll bar**: After zooming in on an image, a scroll bar will be displayed. Right click or Ctrl and click for a shortcut menu with scrolling options.

- **Rulers**: If vertical and horizontal rulers are displayed on the image, right click or Ctrl and click on these to change the method of measurement displayed (for example, cm, inches, pixels). (Also: Ctrl and R, or Command and R on a Mac, will show/hide the rulers.)

↪ **Filename**: In later versions of Photoshop, the filename is displayed as a tab near the top left of the screen. Right click or Ctrl and click on this to close the file, move it to a new window and open more files (documents).

Hot Tip

Drag and drop the Tools toolbar to position it anywhere around the Photoshop screen.

Above: Right click (PC) or Ctrl and click (Mac) around the screen to activate various shortcut menus.

↪ **Layers panel**: If the Layers panel is displayed down the right side of the screen (press F7 to reveal or hide it), right click or Ctrl and click on a layer to manipulate it.

Hot Tip

Lost the Tools toolbar? Click on the Window menu and choose Tools.

WORKING WITH OTHER PROGRAMS AND DEVICES

Photoshop is designed to be able to import and export images and parts of images from and to other programs, ranging from Word and InDesign to devices such as a scanner or camera. The following pages outline some of Photoshop's features that help communicate with other programs and devices.

EXPORTING

There are two methods of exporting an image from Photoshop, which are as follows:

- **Save As**: Save the image as a particular file type that can be opened in the program it is being exported to. Click on the File menu, choose Save As and, from the dialogue box that appears, change the file type to suit.

- **File – Export**: Click on the File menu, choose Export and look down the list of options on the sub-menu. Depending on the version of Photoshop, you may be able to export a path to Illustrator, create a zoom-and-pan image with Zoomview or Zoomify and create a preview image for a video device.

Above: The options on the Export sub-menu vary between different versions of Photoshop and what other features are installed on the computer.

Hot Tip

Press Ctrl (PC), or Command (Mac), and O, and the Open dialogue box will appear.

IMPORTING

Just like exporting, there are two similar approaches to importing:

- → **Open, Open As**: Click on the File menu and select Open or Open As. In both cases, a dialogue box will appear allowing you to choose the file type to open. Selecting a particular file type is useful because it enables Photoshop to display only that file type in a folder or directory, making it easier to locate such files.

- → **File – Import**: Depending on the version of Photoshop and what other software is installed, upon clicking on the File menu and selecting Import, the sub-menu may display options for retrieving images from a digital camera or scanner.

Above: The Open or Open As dialogue box allows specific file types to be selected and displayed.

CUT, COPY AND PASTE

In most cases, objects within Photoshop can be selected, cut or copied, then pasted into another program. Similarly, anything from text to a drawn object can be cut or copied in a

program (especially an Adobe program) and pasted into Photoshop. There are a number of different methods, some of which are more effective than others.

Cut and Copy Text

If some text needs to be cut or copied from a word processor (for example, Microsoft Word), select it and, in most cases, choose Cut or Copy from the Edit menu or toolbar buttons. In Photoshop, the text can be pasted using the following methods:

- **Paste as a layer**: Click on the Edit menu and choose Paste. The text will appear in a box as a separate layer. Click on the Edit menu, choose Transform and select Scale to resize it.

- **Paste into existing text**: Select the Horizontal or Vertical Type Tool from the Tools toolbar on the left side of the screen. Click inside the image to start typing and a flashing cursor will appear. Right click (PC) or Ctrl and click (Mac) on or near this cursor and choose Paste from the shortcut menu. The text will appear and can be changed (resized, new colour or font) by selecting it and altering the settings on the Options bar across the top of the screen.

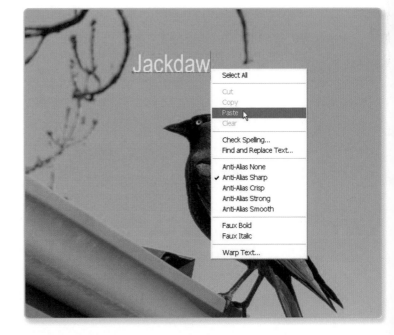

Right: Text can be copied from another program, then pasted into a text layer using the Type Tool.

Copying Text from Photoshop

Text is not always so straightforward to copy from an image in Photoshop. It all depends on how it is displayed, which is explained as follows:

- ➔ **Layer with Type Tool text**: If some text is displayed as a separate layer in an image and was created using the Type Tool, then select the Type Tool again, select the layer from the Layers panel on the right side of the screen and click inside the text. If a flashing cursor appears inside the text, it can be selected (swipe the mouse over it with the [left] button held down) and copied.

- ➔ **Flattened text**: If there are no layers, then the text is not a separate part of the image and can only be selected as a shape. It may be possible, but fiddly, to use the Magic Wand and select all of the letters. The text and its background can be selected using the Rectangular Marquee. However, in most cases, the copied text cannot be pasted as text into another program. It will be pasted as an image.

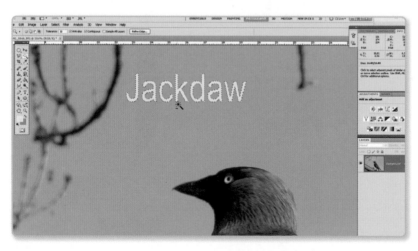

Left: If text is not displayed as a separate layer in an image in Photoshop, the letters can be selected using the Magic Wand.

Paste Images into Photoshop

Images are often straightforward to cut/copy from another program and paste into Photoshop. After cutting or copying an image, return to Photoshop, click on the Edit menu and choose Paste. The cut or copied image will appear as a new layer in the middle of the image, but will probably be in the wrong location. Click on the Edit menu again, choose Transform and select Scale from the sub-menu. A box with small squares will appear around the pasted image. This box can be used to resize and move the image (press Enter/Return to confirm the changes or Escape to reject them).

Hot Tip

If a pasted image needs to be moved, make sure its layer is selected in the Layers panel, then press V on the keyboard and drag and drop it inside the image.

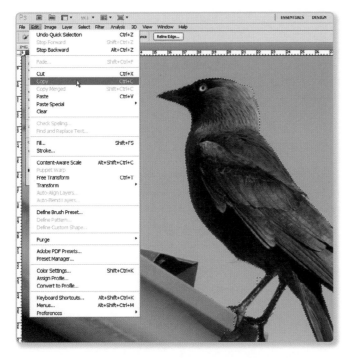

Copy Images from Photoshop

A selection can be copied in Photoshop (click on the Edit menu and choose Copy), then pasted into another program. The results vary on the destination program, but programs such as Microsoft Word and PowerPoint can accept a copied selection from an image.

Left: The jackdaw has been selected using the Quick Selection Tool. After copying it, the selection can be pasted into another program, such as Microsoft PowerPoint.

FURTHER READING

Adobe Creative Team, *Adobe Photoshop CS5 Classroom in a Book*, Adobe, 2010

Bauer, Peter, *Photoshop CS4 for Dummies*, John Wiley & Sons, 2008

Bauer, Peter, *Photoshop CS5 for Dummies*, John Wiley & Sons, 2010

Caplin, Steve, *100% Photoshop: Create stunning illustrations without using any photographs*, Focal Press, 2010

Caplin, Steve, *Art and Design in Photoshop: How to simulate just about anything from great works of art to urban graffiti*, Focal Press, 2008

Caplin, Steve, *How to Cheat in Photoshop CS5: The art of creating realistic photomontages*, Focal Press, 2010

DaNae Dayley, Lisa and Dayley, Brad, *Photoshop CS5 Bible*, John Wiley & Sons, 2010

Evening, Martin and Schewe, Jeff, *Adobe Photoshop CS5 for Photographers: The ultimate workshop*, Focal Press, 2010

Evening, Martin, *Adobe Photoshop CS5 for Photographers: A professional image editor's guide to the creative use of Photoshop for the Macintosh and PC*, Focal Press, 2010

Galer, Mark and Andrews, Philip, *Photoshop CS5: Essential skills*, Focal Press, 2010

Johnson, Steve, *Brilliant Photoshop CS5*, Prentice Hall, 2010

Joinson, Simon, *Get the Most from Photoshop: Improve your photos and produce amazing effects in easy steps*, David & Charles, 2008

Kelby, Scott, *Professional Portrait Retouching Techniques for Photographers Using Photoshop*, New Riders, 2011

Kelby, Scott, *The Adobe Photoshop CS4 Book for Digital Photographers*, New Riders, 2008

Kelby, Scott, *The Adobe Photoshop CS4 Book for Digital Photographers*, New Riders, 2010

Kloskowski, Matt, *Layers: The complete guide to Photoshop's most powerful feature*, Peachpit Press, 2010

Lea, Derek, *Creative Photoshop CS4: Digital illustration and art techniques*, Focal Press, 2009

Obermeier, Barbara, *Photoshop CS5 All-in-one for Dummies*, John Wiley & Sons, 2010

Orwig, Chris, *Adobe Photoshop CS4 How-tos: 100 essential techniques*, Adobe, 2008

Snider, Lesa, *Photoshop CS5: The missing manual*, Pogue Press, 2010

WEBSITES

www.forums.adobe.com/community/photoshop
Official Adobe forum for Photoshop.

www.photoshoptutorials.ws
Useful tutorials on creating specific images in Photoshop, plus links to other websites.

www.adobe.com/designcenter/keyconcepts/articles/concept_index.html
Useful definitions and explanations of Photoshop terminology from the makers of the software.

www.good-tutorials.com/tutorials/photoshop
Various tutorials on creating images and special effects in Photoshop.

www.lynda.com/Photoshop-training-tutorials/279-0.html
Online training courses for Photoshop.

www.photoshopcafe.com
Wide range of information on Photoshop.

www.photoshopforums.com
Popular and organized forum for Photoshop.

www.photoshoproadmap.com
Photoshop tutorials and downloads.

www.photoshopstar.com
Step-by-step guides on specific aspects of Photoshop.

www.photoshoptechniques.com/forum.php
Popular and organized forum for Photoshop.

www.youtube.com
Search for a particular topic in Photoshop and there is usually a video on the subject.

INDEX